LANCHESTER LIBRARY

D1583443

RARY - Art & Design Library

Coventry CV1 5RZ

PIONEERS OF MODERN CRAFT

MANCHESTER
UNIVERSITY PRESS

already published in the series

Henry Ford
Mass production, Modernism and design
RAY BATCHELOR

The culture of fashion
A new history of fashionable dress
CHRISTOPHER BREWARD

National style and nation-state
Design in Poland from the vernacular revival to the international style
DAVID CROWLEY

Manufactured pleasures
Psychological responses to design
RAY CROZIER

The culture of craft
Status and future
EDITED BY PETER DORMER

Eighteenth-century furniture
CLIVE D. EDWARDS

Twentieth-century furniture
Materials, manufacture and markets
CLIVE D. EDWARDS

Victorian furniture
Technology and design
CLIVE D. EDWARDS

Chicago's great world's fairs
JOHN E. FINDLING

Quotations and sources on design and the decorative arts
PAUL GREENHALGH

Graphic design
Reproduction and representation since 1800
PAUL JOBLING AND DAVID CROWLEY

The Edwardian house
The middle-class home in Britain 1880–1914
HELEN C. LONG

general editor
PAUL GREENHALGH

PIONEERS
OF MODERN CRAFT

*Twelve essays profiling key figures in the history
of twentieth-century craft*

EDITED BY MARGOT COATTS

Lanchester Library

WITHDRAWN

Manchester University Press
Manchester and New York

Distributed exclusively in the USA by St. Martin's Press

Copyright © Manchester University Press 1997

While copyright in the volume as a whole is vested in Manchester University Press, copyright in individual chapters belongs to their respective authors, and no chapter may be reproduced wholly or in part without the express permission in writing of both author and publisher.

Published by Manchester University Press
Oxford Road, Manchester M13 9NR, UK
and Room 400, 175 Fifth Avenue,
New York, NY 10010, USA

Distributed exclusively in the USA by
St. Martin's Press, Inc.,
175 Fifth Avenue, New York, 10010, USA

Distributed exclusively in Canada by
UBC Press, University of British Columbia, 6344 Memorial Road,
Vancouver, BC, Canada V6T 1Z2

British Library Cataloguing-in-Publication Data
A catalogue record for this book is available from the British Library

Library of Congress Cataloging-in-Publication Data
Pioneers of modern craft : twelve essays profiling key figures in the
 history of twentieth-century craft / edited by Margot Coatts.
 p. cm. — (Studies in design and material culture)
 ISBN 0-7190-5058-8 (hardback). — ISBN 0-7190-5059-6 (pbk.)
 1. Decorative arts—Great Britain—History—20th century.
 2. Designers—Great Britain—Biography—History and Criticism.
 I. Coatts, Margot. II. Series.
 NK928.P56 1997 96-52329
 745.4'4941'0904—dc21

ISBN 0 7190 5058 8 *hardback*
ISBN 0 7190 5059 6 *paperback*

First published in 1997

01 00 99 98 97 10 9 8 7 6 5 4 3 2 1

Designed by Max Nettleton FCSD
in ITC Giovanni

Typeset by Koinonia Ltd, Manchester

Printed in Great Britain
by Alden Press, Oxford

Contents

List of illustrations *page* vi
List of contributors ix
Foreword x
General editor's foreword xi

Introduction MARGOT COATTS xii

C. R. ASHBEE and the Guild of Handicraft ALAN CRAWFORD 1

EDWARD BARNSLEY ANNETTE CARRUTHERS 12

BERNARD LEACH: rewriting a life OLIVER WATSON 22

EDWARD JOHNSTON and earning a living COLIN BANKS 37

WILLIAM STAITE MURRAY MALCOLM HASLAM 48

PHYLLIS BARRON and DOROTHY LARCHER BARLEY ROSCOE 61

DAVID PYE PETER DORMER 71

MARIANNE STRAUB MARY SCHOESER 83

LUCIE RIE and her work with HANS COPER TONY BIRKS 95

GERALD BENNEY ERIC TURNER 107

DAVID KINDERSLEY and his workshop JEREMY THEOPHILUS 118

GERDA FLÖCKINGER: her modern jewellery TANYA HARROD 130

Illustrations

1 Silver dish with loop handles, designed by C. R. Ashbee, 1901. (Photo: David Cripps. Alan Crawford) *page* 3

2 Woodworking machinery of the Guild of Handicraft, about 1906. (Guild of Handicraft Trust, Campden Trust Collection) 5

3 The Guild of Handicraft encamped below Tintern Abbey, Monmouthshire, 1899. (Felicity Ashbee) 5

4 The Craft of the Guild, from a Guild of Handicraft pamphlet, 1889 8

5 Walnut and ebony cabinet made by Edward Barnsley in 1924. (Edward Barnsley Educational Trust Archive) 15

6 Dining furniture made for Appleby Frodingham Steel Works in Scunthorpe, 1956. (Edward Barnsley Educational Trust Archive) 17

7 Drinks cabinet made by Malcolm Clubley, 1973. (Photo: Harold Lowenstein. Edward Barnsley Educational Trust Archive) 18

8 Portrait of Edward Barnsley, 1936. (Edward Barnsley Educational Trust Archive) 18

9 Raku ware bowl, 1911. (Holburne Museum and Crafts Study Centre, Bath) 24

10 Stoneware vase, 1926. (York City Art Gallery) 27

11 Cut-sided stoneware bowl, 1925-26. (Victoria and Albert Museum) 29

12 Stoneware vase, about 1960. (Crafts Council) 32

13 Central School Certificate with lettering by Edward Johnston. (Central Saint Martin's Art and Design Archive) 38

14 Edward Johnston's blackboard demonstrations. (Central Saint Martin's Art and Design Archive) 39

15 Notes on pens and gilding for the Central School of Arts and Crafts classes. (Central Saint Martin's Art and Design Archive) 41

16 Drawings by Edward Johnston for the Underground Railway Block-Letter, March 1916. (Central Saint Martin's Art and Design Archive) 44

17 'Wading Birds', stoneware vase, 1930 (Buckingham County Museum, Aylesbury). (Sotheby's) 51

18 'Sonata', stoneware vase, 1937-39 (private collection). (Malcolm Haslam) 52

19 Stoneware vase, *c.* 1922 (private collection). (Sotheby's) 55

20 'Standing Buddha', stoneware vase, *c.* 1938 (present whereabouts unknown). (Malcolm Haslam) 56

21 'Elizabethan', designed by Phyllis Barron, 1925. (Holburne Museum and Crafts Study Centre, Bath) 63

22 Peggy Birt and Daisy Ryland hand-block printing in the workshop at Hambutts House, Painswick, 1936. (Holburne Museum and Crafts Study Centre, Bath) 66

23 Sofa upholstered in 'Peach'. (Holburne Museum and Crafts Study Centre, Bath) 67

24 Dorothy Larcher and Phyllis Barron at a street market while on holiday in France about 1930. (Holburne Museum and Crafts Study Centre, Bath) 68

25 'Titanic' 1912. Illustration of collision with iceberg, from *Le Petit Journal*. (Mary Evans Picture Library) 74

26 Stonehenge. (English Heritage Photo Library) 77

27 David Pye in his studio. (Photo: David Cripps. Crafts Council) 79

28 Alan Peters's wood store, 1994. (Photo: Ed Barber) 80

29 Mock leno cloth, linen with gold metallic thread, *c.* 1941. (Mary Schoeser) 87

30 'Goathland', semi-transparent curtain material with spaced Nuralyn warp and fancy cotton weft, 1938. (Mary Schoeser) 88

31 'Pony', warp of cotton fancy yarn with fibro slub and weft of two-ply worsted, 1940. (Mary Schoeser) 91

32 'Silverton', dobby-woven upholstery cloth, 1952-53. (Warner Fabrics plc) 92

33 Lucie Rie and Hans Coper working side by side in Albion Mews, 1950s. (Jane Coper/Alphabet and Image Ltd) 96

34 Straight-handled tableware by Lucie Rie. (Jane Coper/Alphabet and Image Ltd) 100

35 Two large composite forms by Hans Coper, early 1950s. (Jane Coper/Alphabet and Image Ltd) 101

36 Composite forms by Lucie Rie. (Jane Coper/Alphabet and Image Ltd) 103

37 Composite forms by Hans Coper, early 1950s. (Jane Coper/Alphabet and Image Ltd) 104

38 Stainless steel table knives, 'Chelsea' (bottom) and 'Studio' (top). (Victoria and Albert Museum) 111

39 Beaker in silver gilt and enamel. (Gerald Benney) 112

40 Set of candlesticks in silver. (Gerald Benney) 114

41 Clock in silver gilt. (Gerald Benney) 115

42 Memorial tablet for St Albans Cathedral, 1979. (David Kindersley Workshop) 121

43 David Kindersley working on fascia stones for quayside, Dordrecht. (David Kindersley Workshop) 123

44 David Kindersley with examples of figurative carving and lettering, 1994. (David Kindersley Workshop) 126

45 Exterior lettering of Cambridge University Press building. (David Kindersley Workshop) 127

46 Notebook page with a photograph of a ring and associated drawings, mid-1950s. (Gerda Flöckinger) 133

47 Detail of necklace in silver with cabochon quartz, early 1960s. (Gerda Flöckinger) 134

48 Silver bracelet 1968. From the catalogue *Flöckinger/Herman*, Victoria and Albert Museum, 1971. (Photo: Mark Hamilton) 136

49 A pair of rings in 18-carat gold, 1993. (Gerda Flöckinger) 139

50 Ear-rings in 18-carat gold (private collection). (Gerda Flöckinger) 140

The publisher is grateful to the sources cited for permission to reproduce the illustrations

The Contributors

Margot Coatts is an independent exhibition curator, writer and lecturer in twentieth-century applied arts

Alan Crawford is a freelance writer in the field of architectural history and the history of the decorative arts

Annette Carruthers is a lecturer in the School of Art History at the University of St Andrews

Oliver Watson is Chief Curator of Ceramics and Glass at the Victoria and Albert Museum

Colin Banks is a graphic designer and typographer and a partner in Banks & Miles

Malcolm Haslam is a decorative arts historian and writer

Barley Roscoe MBE is Director of the Holburne Museum and Crafts Study Centre, Bath

Peter Dormer was a writer and critic and the first Fellow in Critical Appreciation in the Applied Arts at the University of East Anglia

Mary Schoeser is a consultant historian, archivist and curator

Tony Birks is a painter, sculptor and biographer of Lucie Rie and Hans Coper

Eric Turner is Assistant Curator in the Department of Metalwork, Silver and Jewellery at the Victoria and Albert Museum

Jeremy Theophilus is Senior Visual Arts Officer, Arts Council of England.

Tanya Harrod was Visiting Fellow in Critical Appreciation of Craft and Design at the University of East Anglia 1995–7

Foreword

T HE CRAFTS COUNCIL is the national body committed to the promotion of the contemporary crafts in Great Britain. It is an independent organisation funded by government and provides services to craftspeople and the public through its programme of exhibitions, educational events and sales development work. Its premises in Islington, London, house the exhibition galleries, gallery shop, reference library and administrative offices.

As part of its national remit to inform the public of the work of contemporary craftspeople, twelve lectures were arranged which highlighted key figures in the historical development of twentieth-century craft practice. This book is based on the texts of these lectures.

General editor's foreword

I T IS no coincidence that one of the first and most important studies ever written on the visual arts, Georgio Vasari's *Lives of the Artists*, was a work of collective biography. In the creation of the literature of any subject in the humanities, biography is a vital stage of development. Without it little else can really evolve. From this perspective, the written history of the crafts is in an important phase, one we might refer to as *the monograph stage*. The present volume presents the careers and ideas of some of the most important craftspeople of the twentieth century. Written by essayists of international authority and edited by one of Britain's leading craft historians, it provides important new material which will be of use to all in the field. Each essay, as well as recounting the individual careers of their subjects, also positions each oeuvre within the century and provides a critical perspective.

This volume could not have been produced without the support of the Crafts Council of Great Britain. As part of its national remit to inform the public of the work of contemporary craftspeople, the Crafts Council ran the series of twelve lectures which are the basis of the volume. The Crafts Council also sponsored its production. Its premises in Islington, London, houses exhibition galleries, a reference library, an administrative centre and a shop.

PAUL GREENHALGH

Introduction

THIS BOOK of essays is based on a series of lectures arranged by the Crafts Council which took place at its London headquarters over the winter months of 1993–94 and 1994–95. From the outset the lectures were intended for publication as essays collected in a single volume and, as series co-ordinator and editor, my ambition was to secure speakers who were authoritative and experienced writers on the 'pioneers' of modern British craft in the pre-war and post-war periods. This need for writer-lecturers helped, in a sense, to establish our roll-call of subjects which, of course, will remain contentious.

Original, in-depth, historical work was essential to our project, and pointed to people such as Alan Crawford, Annette Carruthers, Malcolm Haslam and Mary Schoeser for their respective monographs on C. R. Ashbee, Edward Barnsley, William Staite Murray and Marianne Straub, all published in the 1980s. The same sense of empirical investigation was of course shared by other writers on craft history subjects, in essays published in specialist journals and catalogues of exhibitions or museum collections. Here, for instance, curatorial research into the making and character of a specific group of objects had led to the formation of a broader picture. In this category are Oliver Watson's writings on Bernard Leach, Barley Roscoe's on the handblock-printers Phyllis Barron and Dorothy Larcher and Peter Dormer's on David Pye. All prepared new appraisals of their subjects' contributions to the world of craft for this book.

An important aspect of the selection of pioneers was the desire to include in each series of six lectures one 'representative' of each of the enduring artistic craft disciplines of the twentieth century. For the purposes of the exercise we took these to be: furniture and woodwork, metalwork and jewellery, ceramics, textiles, and lettering and writing. By

this process, inevitably, omissions occur, and the axe had to fall on areas such as glass, bookbinding, and the architectural crafts including ironwork and stained glass. None of these areas, which developed interestingly at various times and speeds, appear in this book.

One of the reasons for this is that leading single figures are less easily identifiable in those crafts, due to the fact that workshops for glass or iron were, until the 1960s, more commonly operated and defined as 'team' activities, and seen as trade units carrying out the designs of artists or architects more than the ateliers of artist-craftsmen. The situation is altogether different in ceramics where a variety of possible potter-subjects exists, all working under their own names, who form by far the largest group of active craftworkers in Britain in the second half of the twentieth century. Taking this into account, it was finally decided to include four potters, combining them into three essays in this book: Leach and Staite Murray in the pre-war grouping, followed by Coper discussed with Rie in the post-war. This avoided taking a partisan view of the sharply divided camps which existed in the earlier period over the ideologies and attitudes of Bernard Leach and William Staite Murray, and which, interestingly, still faintly persist among potters today.

Hard decisions had to be taken, however, in areas other than ceramics – namely, in silver and in woven textiles. In the former, Gerald Benney was chosen above Robert Welch (the two are exact contemporaries), and in the latter Marianne Straub over Ethel Mairet. These two particular decisions were the indirect result of my own role as chairperson and editor of the project. Welch and Mairet are two figures in craft history on whom I myself have written monographs and so, if for any reason other speaker-authors failed to deliver the goods, it was for me to step in! This contingency plan did not prove necessary.

Early in discussions it was decided that being a pioneer did not necessarily mean being a craftsperson all one's life, in terms of getting one's hands dirty. The definition could include being an entrepreneur (C. R. Ashbee), a translator into multiple production (Marianne Straub or Edward Johnston) or a teacher (David Pye or Edward Barnsley). The job actually demands that the individual is a little of all three. We decided, conclusively, to root our subjects in the twentieth century, since we were working almost at its close, and not to cross well-travelled ground in seeking out John Ruskin and William Morris.

And so it was decided to introduce the 'pioneers' with a study of C. R. Ashbee, operating up to the end of the first decade of the century. Ashbee, architect, designer, socialist and leader of the Guild of Handicraft, stood for multi-disciplined craft activities, shared ideals and a social and cultural life in which he and his workers took part. As the century wore on, this collaborative approach, with a predilection for alternative communities, such as those of Ditchling or Dartington, can be seen to turn more and more to a singular, personal ideal. Workshops generally decreased in size and limited themselves to one medium.

In the fourteen prominent figures described and analysed here it is possible to perceive a marked drive, even dedication, which flows from their conviction to improve not only their products but to consolidate the professions in which they earned, or earn, their livings. This, coupled with a consuming interest in the fundamental processes of making, is the thread that unites these men and women. Theirs is a minority occupation retaining many hand skills, in a century which has been dominated by rapid technological change.

It is misleading to propagate, however, the false notion that twentieth-century British artist-craftspeople are, or have been, embedded in a time-warp of medievalism and obscurity, or have little desire to communicate, travel and develop. The evidence provided by the authors of this collection of essays shows the case to be different. David Kindersley, for example, ran his Cambridge workshop, largely producing cut inscriptions and memorials, for over forty years; he also developed for commercial use a letter-spacing system which was taken up by Letraset for dry transfer-lettering. In textiles, Barron and Larcher, the handblock-printers of the 1930s and 1940s, worked for clients in the forefront of fashion and decorating and took on certain orders for fabrics which, although large enough to ensure stylistic impact, retained an aura of exclusivity. With woven textiles, the work of the handloom-trained designer, Marianne Straub, broke new ground aesthetically, specifically through simple spacing adaptations to loom threadings. Straub also encouraged heightened appreciation of yarn quality in industry via her long association with Warner Fabrics. In studio pottery, Bernard Leach was the greatest ever craftsman-proselytiser, who ceaselessly travelled, lectured and published on his subject.

Wood and furniture have always provided durable products which are

the natural companions of architecture and interior design. The Cotswold School of architecture-trained furnituremakers provides what are often regarded as the most typical pioneers. It is represented here by C. R. Ashbee and also by Edward Barnsley. Barnsley, the son of Sidney Barnsley and the Cotswold School's direct successor, was brought up with arts and crafts design principles at the breakfast table but was later able to involve himself in modern craft educational and promotional initiatives. In her essay, Annette Carruthers reveals him as a respected teacher at Leicester College of Art and an instrumental figure in the founding and running of the Crafts Centre of Great Britain at Hay Hill, Mayfair, in the early 1960s.

Silversmiths and jewellers have traditionally been patronised by royalty, civic and church authorities and, of course, by private individuals. Workshops operating since the Second World War have, in addition to working in the traditional areas, acted as the providers of modern talismans and trophies for sports, arts and industry; they may yet prove to be the providers of the most enduring and symbolic craftwork of our century. Gerald Benney, discussed by Eric Turner, and Gerda Flöckinger by Tanya Harrod, have shown special tenacity in metalwork as well as startling technical virtuosity and aesthetic invention.

Although nearly every craftsperson examined in this book was a gifted teacher, none could have been more influential than David Pye and Edward Johnston. Two essentially private men, they are evaluated by Peter Dormer and Colin Banks respectively for their comment and writings. Both were important at London art schools: Johnston taught lettering and calligraphy at the Central School of Arts and Crafts in the first two decades of the century and Pye furniture design at the Royal College of Art in the 1960s and 1970s.

So why set down in print a collection of essays on fourteen such different people's working lives in a minority cultural activity? It is partly to establish some ground rules for marking out the scope of the modern decorative crafts. In the minds of many consumers, the crafts are no more than an adjunct to interior design 'styling', something to fill a space in a photograph. In the context of present-day 'house' magazines the crafts have been represented as the sequel to a back-to-the-land movement, and all that implies: rural retreats, health foods and a cultivated unsophistication. These very generalisations devalue the vast creative efforts behind every aspect of the crafts movement, and the people who shaped it.

The reason I offer, therefore, for publishing these essays now is simple. We do it because in the mid-1990s it is appropriate to set down as a clear historical record and in carefully balanced statements exactly what happened in a pioneer craft workshop, and if possible in a craftworker's mind, at a given date in our own time. Time is of the essence when collecting biographical information, especially when it is not to be found in the classical sources of registers, printed documents, minutes and official papers. Working from the particular to the general – in this case from the individual's products, workshop papers and writings, from reports of initiatives made by that individual in the furtherance of his or her craft – and using the most acute of observers and commentators available, is surely the most effective and interesting way of achieving this.

MARGOT COATTS

The object is not the object: C. R. ASHBEE and the Guild of Handicraft

ALAN CRAWFORD

CHARLES ROBERT ASHBEE was not a craftsman. He devoted much of his life to craftsmen, but he moved in and out of their world with disconcerting ease. He was an unusual mixture of teacher and visionary, intellectual and entrepreneur, and he refused to be pigeon-holed professionally. If asked to describe himself, he would probably not have said that he was an architect, a designer, an educator or a businessman, though he was all these things. He would have said something about having ideas, and putting them into practice.

He was born in London in 1863. His father was a businessman and his childhood was that of the affluent middle class. He was educated at public school, which he hated, and at Cambridge University, which he loved, not for its academic studies but for its friendships and idealism. He talked long into the night with young, high-minded friends. Plato was a favourite theme, and the physical world as an image of a greater, spiritual reality. The 'social question' was another; these young men could see the great gap between rich and poor in late Victorian society, and it disturbed them. They thought of themselves as socialists, in a broad sense that was not specifically political.

Ashbee was good at art, and it was probably at Cambridge that he first read the writings of John Ruskin. Ruskin denounced the materialism of nineteenth-century industrial society like an angry Old Testament prophet. And he did so in the name of its own Romantic values: nature, art and the simplicities of everyday life. Reading Ruskin suggested to Ashbee that this interest in art might be a vehicle for his socialism. When he left Cambridge in 1886 he did not know exactly what he wanted to do,

but he knew it had to be in Ruskin's direction. And so it was. His life had its share of failure and changes of fortune, but he did not lose the convictions he had formed at Cambridge.

He became a pupil of the architect G. F. Bodley in London. But he did not live in his father's big house in Bloomsbury, he lived at Toynbee Hall in the deprived, working-class district of Whitechapel. Here Oxford and Cambridge graduates did voluntary work, spreading a healing sense of middle-class values, it was hoped. Ashbee ran a reading class on Ruskin at Toynbee Hall and from this developed the idea of a permanent workshop. In 1888 Ashbee set up the Guild of Handicraft, in an attic next door to Toynbee Hall. It was to be his life's work. Three years later, the Guild moved to a handsome eighteenth-century mansion called Essex House in the Mile End Road.

Ruskin had written of the freedom and happiness of the workmen who carved the stonework on the buildings of the Middle Ages, of an experience utterly different from the precise and mindless repetition of factory work in the nineteenth century (or, at least, of factory work as Ruskin understood it). The Guild of Handicraft was to be a place where the modern English workman could find that freedom and happiness. The work would be done by hand, and creative experience would be the touchstone of value. There were four workmen at first: John Pearson, a skilled metalworker with an established style in *repoussé* work; C. V. Adams, a cabinetmaker and trade unionist, who gave the workshop its progressive, co-operative structure; and John Williams and Fred Hubbard, who were unskilled. In some ways Ashbee preferred the workers to be unskilled as he distrusted experience in the trades. He was young himself; Pearson had more experience as a craftsman, Adams in organisation. But Ashbee had the energy of an idealist, the beginnings of a talent for design, and the advantages of being middle-class. He led the Guild.

During most of the history of the Guild of Handicraft, Ashbee supplied the designs. What he drew was only a starting-point for the craftsmen and he probably did not prize his designs in themselves. He certainly did not think that the Guild existed to execute them. Indeed, he hoped that the Guildsmen would develop their own collective habits of working, a Guild style. In that sense John Pearson, with his already established style of *repoussé* work, was a false start. In about 1890 Ashbee began to explore the quite different process of casting, and especially the

technique of lost-wax casting, learning to do it himself and working closely with one of his metalworkers, Bill Hardiman, who had a particularly delicate touch.

This was a way of going back to the beginning, learning together. They produced cast medallions, the earliest form of jewellery made by the Guild, and small castings for cups and other silverware. These scarcely amounted to a Guild style and in time disappeared from the repertoire. But it was the process that mattered at this stage, not the objects. Ashbee and his metalworkers evolved a little bit of tradition, a mutuality between designing and making. It was not a fully collective way of working, but it established a rapport which is felt in the increasing fluency of Guild metalwork during the 1890s. The loop-handled dishes produced from the late 1890s, for instance, reflect workshop practices as well as the elegant economy of Ashbee's designs: they were, I believe, kept simple so that less-than-expert craftsmen could have the satisfaction of making them. Creative experience mattered more to Ashbee than high skill.

By 1900 the Guild was large and successful, with more than thirty employees. Of the original workshops, the cabinetmakers continued much as before, but the metalworkers had developed new specialisms in silverware, jewellery and enamelling. A blacksmith's shop was added in 1890, and in 1898 Ashbee took on the workers and equipment from

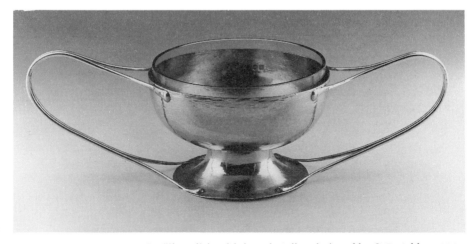

1 Silver dish with loop handles, designed by C. R. Ashbee, 1901

William Morris's famous Kelmscott Press, to form his own Essex House Press. Thus in its heyday the Guild consisted of five or six workshops, practising a motley collection of trades. The Arts and Crafts movement encouraged multiple workshops of this sort, though it is difficult to see the rationale of having jewellers and blacksmiths under the same roof. Some early Arts and Crafts organisations, like Morris and Co. and the Century Guild, set themselves up as an 'artistic' alternative to established furnishing and decorating firms, and thus had to provide a comparably broad service. The Guild of Handicraft was not like that. Its range of workshops seems to have been a reflection of Ashbee's enthusiasms. Arts and Crafts people liked to experiment with different media, and perhaps multiple workshops were simply an aspect of their versatility.

As the Guild grew, some of the old intimacy was lost, and Ashbee became more of a manager. When it became a limited company in 1898, he had to deal with shareholders and a board of directors. This did not affect the cabinetmakers, who had always wanted to be told what to do – 'the stolid Trade Union shop' is how Ashbee described them.[1] But the delicate relationship which he had built up with the metalworkers in the early 1890s seems to have given way to something more structured. The design was still just a starting-point; journalists remarked on how sketchy and open to interpretation Ashbee's drawings and instructions for the craftsmen were.[2] But when Hermann Muthesius, the most acute observer of English design, came to write about the Guild in 1898, he judged that the craftsmen were, artistically speaking, dependent on Ashbee.[3] George Hart, who joined the Guild as a metalworker in 1901, told me how it worked in practice.[4] He said that Ashbee's habit was first to make just a rough sketch for the craftsman and then, on his regular tours of the workshop, he would talk it over with the craftsman who would take the design further.

Most of the equipment and processes used in the Guild belonged to handwork. Ashbee believed that machines had a part to play in a modern craft workshop, in the preparation of materials and other routine processes, but he was afraid that their wider use might pose a threat to creativity, that they might disturb, as he put it, 'the economy and inventive power of my workshop'.[5] Thus, in the Guild of Handicraft, the preparation of timber was done, at least in the later years, in a separate shed with a band-saw, plane and circular saw run off an electrically-powered shaft. In

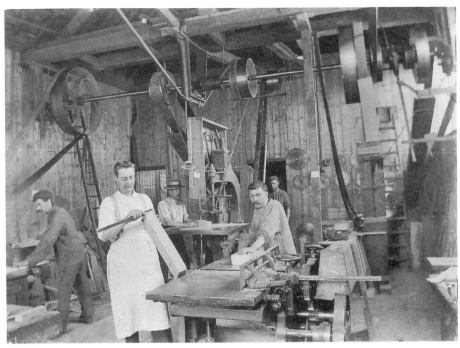

2 Woodworking machinery of the Guild of Handicraft, about 1906

3 The Guild of Handicraft encamped below Tintern Abbey, Monmouthshire, 1899

the workshops themselves, the cabinetmakers used a lathe, morticing machine and trimmer, probably powered by foot or hand, while the metalworkers had electrically powered equipment for polishing and buffing. This was a simple arrangement, and I do not know that it caused great problems. 'The machine' was not an issue in the way that it was, and still is, in intellectual discussions about modern craftsmanship.

For most of his life Ashbee kept a detailed and often very vivid journal. Around 1900 it is full of the goings-on of the Guild, though not of its working day, unless some incident of human interest had happened. It is the out-of-hours life of the Guild, and the antics of Guild apprentices called Sid and Jacko and 'The Professor' that Ashbee wrote about. There was supper for the Guildsmen once a week, and after that they would have a 'sing-song' – Ashbee taught them folk-songs and urban ballads, trying to keep them away from music-hall ditties. At Christmas they would rehearse and perform the Guild play, sometimes Shakespeare, sometimes, more ambitiously, Shakespeare's then little-performed contemporaries – Ben Jonson, Beaumont and Fletcher, Dekker. In the summer he would take the young men out into the country for a week or so, rowing down one of the English rivers. And all this was part of the Guild experiment for Ashbee, not marginal activity at all. The rediscovery of folk-song as a musical vernacular and the revival of Elizabethan and Jacobean drama as verse rather than theatrical upholstery were preoccupations of the avant-garde in London around 1900; but for Ashbee they were also an opportunity to enlarge the experience of his Guildsmen. Progressive taste and social responsibility were merged, as they were in the workshops of the Guild.

The lease on Essex House in Whitechapel was due to expire in 1902, and Ashbee began to look around for the Guild's new home. At one point he considered moving it to Chelsea, where he lived, but his real hope was to get right out of London. In the summer of 1901, on the way back from the Guild river trip down the Severn, he went to look at the little town of Chipping Campden in the north Cotswolds. He found a long high street lined with handsome houses in grey-brown stone, most of them dating from the fifteenth to eighteenth centuries; he found an early eighteenth-century silk mill, long vacant and perfectly suited to be the workshops of the Guild; and he found a number of houses apparently standing empty, as if waiting for the Guildsmen to move in. It seemed as if, for the previous fourteen years, he had been carrying on his experiment in pre-industrial

craftsmanship in the wrong place. It was made for Campden. At Christmas the question of the move was debated in the Guild, and the men voted decisively in favour. Between May and August 1902, the various workshops of the Guild were transferred from Mile End to Chipping Campden, and in all some thirty craftsmen made the move. With wives and families as well, this meant an addition of about 150 people to the population of the town, which then stood at 1500.

The move to Campden is the best-known episode of Ashbee's career, and it has seemed so typical of the Arts and Crafts movement that it is hard not to treat it as inevitable. But it was, as so often with Ashbee, shaped by particular ideas and ideals. This was the time of the Boer War, when the British Empire seemed to be held to ransom by a handful of farmers. In the poorest areas of cities, and the East End of London was among the worse, the recruiting officers were continually turning men away as they were unfit to fight. It seemed as if the growth of cities in the nineteenth century had sapped the strength of the nation. Ashbee was always sensitive to current social issues, and in moving the Guild to Campden he was responding to concern over the health of the nation.

He also thought that the natural place of the crafts, the workmanship of the pre-industrial era, was in the country. When the Guild voted in favour of the move, Ashbee was in Oxfordshire. Lewis Hughes, the Welsh blacksmith, took the train to Oxford and walked eight miles through the snow to bring him the news. 'I am glad', Ashbee wrote in his journal, 'to think that the men themselves have decided that on the whole it is better to leave Babylon and go home to the land'.[6] A moment's reflection would have told Ashbee that cabinetmakers, silversmiths, jewellers and printers had never known the country as their 'home'; these were urban crafts. But the Romantic identification of crafts with the countryside was very strong in him, and in the Arts and Crafts movement as a whole.

For a few years, the story of the Guild in Chipping Campden was a happy one. Ashbee's journals give an idyllic sense of all goals achieved. The home of the Guild was now healthier and, Ashbee thought, more conducive to good craftsmanship. And Chipping Campden itself, after an initial shock, seemed to benefit from the liveliness of the newcomers. But in 1904 sales were down. They did not improve sufficiently over the next year, and in 1906 a business manager was appointed to deal with aspects of running the Guild that Ashbee had never found congenial. But his best

efforts were not enough. At the end of 1907 it was decided that the Guild as a limited company should go into liquidation. Ashbee blamed this failure on a downturn in the market, but if the truth be known the root of the problem lay closer to home. In London when times were bad the Guild would lay workers off, and they could come back when things picked up. In Campden, you could not lay men off; there was nowhere for them to go. The Guild had lost its flexibility. Ashbee had forgotten how urban the Guild of Handicraft was.

Liquidation was not the end of the Guild. Some craftsmen stayed on in Campden working under their own names and the Guild continued to

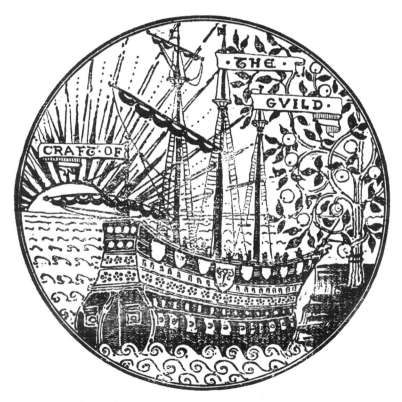

4 The Craft of the Guild, from a Guild of Handicraft pamphlet, 1889

meet, with Ashbee in the chair. But his work had lost its focus. He had great energy, good contacts and a freelance habit of working, so this was far from the end of his story. In the early 1920s, he could be found in Jerusalem no less, repairing the historic fabric of the city, and encouraging the revival of native Palestinian crafts. But the Guild of Handicraft had been the vehicle of his idealism. It was his work, as dishes and bowls were the work of his silversmiths, and his life was not the same without it.

Ashbee liked to use symbols or emblems in his designs. They were a physical expression of a spiritual reality, an image of the idealism that lay behind the object itself. One of them was a ship, known as 'the Craft of the Guild'. On one level, this was a clumsy pun. On another, it was an emblem for a journey, an endeavour, for Ashbee's imagery was based on traditional Western symbolism. The Craft of the Guild was a brave little ship and it carried a lot.

Nowadays 'the crafts' are a specialised kind of artistic activity. Most craft objects are made by people who learned to do it at art school, and they are bought by people for whom they are a luxury of taste. Ashbee did not see the Guild of Handicraft like that. It was not about art, it was about work. It was not about special people with talent, but about talent in ordinary people. (We feel the ship getting heavier.) The aims and ideals of the Guild were not achieved once a fine piece of workmanship had been produced – the object was not the object – they were achieved as the workman's experience became more creative. (Now the ship is weighted with ambitions.) Ashbee's great, over-arching Ruskinian belief was that the crafts could be a vehicle of social reform, a way of making the world a better place. (The ship is sometimes shown setting sail, an image of hope. But there is no image of it reaching port.)

On the other hand, there were things not on board this Guild ship – skill, design, a sense of materials – qualities which many people would say were crucial to craftwork. They were present in some of the work of the Guild but they were present unevenly. Certain later jewellery and enamel-work is very skilled. Ashbee's silverwork designs around 1900 are among the finest of the Arts and Crafts movement, and part of their quality is an acute sense of the sheen, rather than the shine, of silver. The books of the Essex House Press are well made, thanks to skills the printers had learned with William Morris, but they are mannered in design, for Ashbee was in too much of a hurry, too much a jack of all trades, to adapt to the patient,

technical, traditional work of typography. This unevenness did not matter to him because skill, design and a sense of materials were, for Ashbee at least, not crucial to his experiment. In the early years he used to choose his workmen with a steady gaze into their eyes and a firm grasp of the hand; he thought he could judge character that way, and character mattered more than skill. As for design, you could read his journals from end to end, and never know that he was a designer.

He stood apart, even in his own time. There were many Arts and Crafts workshops in London in the 1890s, but there was only one in the East End. Talking about Ashbee to the architect Nikolaus Pevsner, H. S. Goodhart-Rendel once said, 'If you had taken him up, you were really in with the revolutionaries'.[7] Goodhart-Rendel was an urbane high Tory, oil to Ashbee's water; but there was truth in what he said. For Ashbee more than for anyone else in the Arts and Crafts movement, more perhaps than for William Morris, the meaning of craftsmanship was social.

Ten years ago, when I had to devise a subtitle for a book about Ashbee, I came up with *Architect, Designer and Romantic Socialist*.[8] It was not a good subtitle – the last part makes you think of the sexual escapades of George Bernard Shaw – but it was the right one. The socialism that Ashbee learned in the 1880s was not exclusively political and it had not even begun to be parliamentary. It had its roots in the Romantic sense of humanity as organic and essentially creative, in the poems of Wordsworth, Shelley and Keats, and in the social criticism of Carlyle and Ruskin. It was part of a whole brew of radical ideas that included sexual liberation, occult religion, vegetarianism and the simple life. Ashbee held on to the values that he had learned at Cambridge in the 1880s. (His tenacity sometimes looks like strength and sometimes like *naïveté*). His whole career was shaped by them. Whatever place he has in the modern revival of the crafts, he earned it in the name of values learned more than 100 years ago.

Notes

1 Entry for 25 December 1901 in the Ashbee journals, King's College, Cambridge.
2 See for instance *The Studio*, vol. 18 (1899), p. 118; *Kunst und Kunsthandwerk*, vol. 3 (1900), pp. 173–4; *Craftsman*, 5 (Eastwood, NY, 1908), p. 174
3 *Dekorative Kunst*, 2 (1898), p. 47.

4 Interview, July 1969.

5 C. R. Ashbee, *Modern English Silverwork* (Broad Campden, 1909), p. 8.

6 Entry for 25 December 1901, Ashbee journals.

7 *Architectural Review*, 138 (1965), p. 263.

8 A. Crawford, *C. R. Ashbee: Architect, Designer and Romantic Socialist* (London and New Haven, 1985).

EDWARD BARNSLEY

ANNETTE CARRUTHERS

I N ITS MATURITY Edward Barnsley's work as a maker of fine furniture reflected his personal response to changing twentieth-century condi- tions, yet it was always firmly rooted in his first-hand experience of the Arts and Crafts movement at its most principled. He was born in 1900 at Pinbury, near Cirencester in Gloucestershire, where his father, Sidney Barnsley, had settled in 1893, intent on forming a craft community with his brother, Ernest, and their friend and colleague, Ernest Gimson. Inspired by the idea of the simple life in the country, and encouraged by William Morris to become practical builders and craftsmen rather than drawing-board architects, the three young men shared a workshop for some years, experimenting with woodworking and other crafts.

During this time they developed a distinctive style, suited to a range of household furniture. It was based on their increasing technical knowl- edge, gained by careful observation and practice, and on a profound understanding of materials. Furniture from their hands was usually of solid English timber, with dovetails, tenons and other constructional elements developed into forms of decoration. Features were adapted from ancient pieces in museums, churches and houses, their preference being for work from before the eighteenth century and for unfashionable country furniture. Inspiration also came from wheelwrighting and other agricultural crafts and from more exotic sources, such as a Gujerat travel- ling box in the Victoria and Albert Museum.

After some years of working together in a casual way, Ernest Gimson and Ernest Barnsley, in a short-lived partnership, took on trained cabinet- makers to execute their designs. All three moved from Pinbury to nearby

Sapperton in 1902 and Sidney Barnsley set up a workshop by his home. From quiet beginnings they built up a reputation, and by 1916 Gimson was widely acknowledged as a leader in furniture design. Sidney Barnsley was less well known, mainly because working alone in general he produced fewer pieces, but his dedication as a designer-maker is increasingly appreciated, and some consider his rugged furniture the height of achievement in the Arts and Crafts movement.

Edward Barnsley grew up in this atmosphere of dedication to the design and execution of craftwork in an unspoilt rural situation. In 1911 he was sent to Bedales, a progressive school near Petersfield in Hampshire, which encouraged pupils to participate in practical activities. Here he flourished, becoming head boy in 1917, and taught woodwork briefly when the teacher was called up for military service. On being offered a permanent post in 1919, Barnsley was advised to gain some real experience before embarking on a teaching career. He had always made things in his father's workshop and assumed he would train with Gimson, though Sidney Barnsley believed it would be impossible to make a real living at cabinet-making. Gimson died in 1919, but his designs for a new library at Bedales were to be executed by Geoffrey Lupton, an ex-pupil of Gimson's and himself an Old Bedalian. Here was the opportunity Edward needed for practical experience, and he spent three years with Lupton, enjoying hard physical work and the challenge of a large-scale building project in wood.

A visit to the staffroom at Bedales convinced Barnsley that teaching was not for him, and in 1922 he attended the Central School of Arts and Crafts in London, an experience that had surprisingly little impact on him. The following year, Lupton decided to give up his business and offered to lease his workshop at Froxfield to Edward, who happily took over premises and staff. He received so much work from Lupton and others that he was able to take on his first apprentice, Herbert Upton, in 1924. Lupton then sold to Sidney Barnsley the workshop, garages and sheds, several cottages, and about an acre of land, all on a steep hill above Petersfield, a few miles from Bedales. Lupton's own cottage, built in 1909, was home for Edward and his wife, Tania, after their marriage in 1925, and he always felt privileged to live amidst the ever-changing natural beauty of this place.

Thus, at the age of twenty-five, Edward Barnsley had a property leased from his father, a workshop employing five makers, and a fair amount of

work. He was happy to undertake architectural woodwork for contemporaries such as Alister MacDonald and old family friends like Robert Weir Schultz, enjoying this scale of commission. His furniture was made of solid English timber, with revealed construction, fielded panels, handmade metal handles, and all the distinctive features of the Cotswold style. It was not always as well made as it could be, and sometimes incorporated features of which his father would not have approved because they defied Arts and Crafts principles of honesty of construction. Barnsley did not have to develop his style from first principles, but adopted it ready-formed. In later years, when he was thinking through his work in a more personal way, inconsistencies were usually avoided. Also, a lack of capital occasionally tempted him to make do with substandard materials, as when in 1926 he supplied a dressing table to Rodmarton Manor and was mortified when the client, Mrs Biddulph, noticed one drawer had a plywood bottom.

Many of the earliest pieces were made to Sidney Barnsley's designs, so the close relationship of Edward's work to that of his father is no surprise. From the beginning, however, he made minor changes to the proportions and the shapes of rails and feet, and by the late 1920s he was incorporating features with a flavour of art deco, including stepped tops and zigzag flashes on radio cabinets. He later regretted the sunray motif on a wardrobe of 1928, and he played down the extent to which he had been influenced by fashion in the 1920s and 1930s, but the workshop also produced a number of severe, almost Modernist, veneered pieces at this time. Without suitable equipment this was not easy, and it is not known if he designed these pieces through preference, to oblige existing clients, or because work was desperately needed when business was bad. Much later, Barnsley wrote of the contradictions of producing by hand something that looks as if made with machine tools and processes, and it is interesting that he turned away from this.

In the early 1930s, Barnsley's order book was so badly affected by the Depression that he considered closing the workshop and finding work as a freelance designer. His lack of business experience meant he had rarely made much profit and often lost money on pieces that he had estimated incorrectly, and he had no reserves to keep him going. Tania went out to work so that craftworkers would not have to be laid off, and paying pupils were also taken on. Numerous small items were produced, such as lamps, boxes and turned bowls, but it was impossible to survive on the income

5 Walnut and ebony cabinet made by Edward Barnsley
in 1924 in typical Cotswold style

from these alone. At the 1931 Arts and Crafts Exhibition, Barnsley was saved by the sale of a large sideboard, and a few years later an unexpected legacy paid off his overdraft. More permanent assistance came in 1938 with the offer of the post of Design Adviser at the East Midlands Training College in Loughborough, a part-time job that underpinned the Barnsley workshop until his retirement from Loughborough in 1965. The importance of this in the late 1930s was that the contact with the students encouraged Barnsley to consider the issues involved in design and why his work as a craftsman was essential to him. This may be what prompted him, in the changed conditions of wartime, to become involved in planning for the future of the crafts.

By the time of the First World War, there had been widespread recognition that Arts and Crafts ideals had not been achieved. Gradually, many of the generation of architect-designers contemporary with Gimson and the Barnsleys found their work was no longer in demand. William Morris's socialist message about the importance for all of useful and interesting work in pleasant surroundings became lost in the contradictions of craft production, the expense of handmade goods and the impossibility of competing on equal terms within a capitalist system. In the 1920s and 1930s, the kind of idealism shown by Arts and Crafts enthusiasts turned towards a new hope, that all could enjoy well-designed and attractive goods made cheaply by machine methods. The working life of the maker was no longer considered of prime importance in comparison with the education of the manufacturer and consumer in good design. Even within the Arts and Crafts Exhibition Society in London, the bastion of earlier values, it was suggested that the justification for handwork was in making prototypes for manufacturers and that the craftworker had a moral duty to design for industry if possible.

In the spirit of reassessment engendered by world war, Edward Barnsley and his friend Roger Powell, along with Bernard Leach, Harry Norris and others, began to reclaim the idea of craft for its own sake. Attempting to ensure that some craft skills were preserved and that craftworkers would be better regarded in society, they reasserted their belief that satisfying work with hand and brain had an important place in a civilised world, and that more people should be able to live by such work.

Barnsley was closely involved in these debates and in 1944 was elected Deputy President of the Arts and Crafts Exhibition Society,

6 Dining furniture made for Appleby Frodingham Steel Works in Scunthorpe, 1956

working with the President, John Farleigh, towards establishing a centre in London. After years of effort, the Crafts Centre of Great Britain was opened at Hay Hill in 1950 as a showplace for the crafts. Significantly, for the first time, the crafts received financial support from the government.

This campaigning had several effects for Edward Barnsley after the war. In 1945 he was awarded the CBE for his contribution to design and as a result became more widely known. He was appointed to the Advisory Council of the Victoria and Albert Museum, received commissions from the Ministry of Works, and was invited by the Rural Industries Bureau to become its Furniture Consultant and supply designs for use by other makers. This brought him substantial fees for some years and introduced him to enthusiasts with whom he discussed technical and business issues.

Involvement with the Arts and Crafts Exhibition Society, and specifically with an exhibition organised in 1944 to show the quality of British craftwork, led to a change in Barnsley's style, prompted by criticisms from John Farleigh. The exhibits were undoubtedly beautifully made, he said, but were dull and heavy and unsuited to the spirit of the coming age. Almost immediately, Barnsley's furniture began to express a lighter mood and he gradually developed a more personal style, influenced also by the new technical skills of his foreman, Bert Upton, who had spent the

7 Drinks cabinet in English walnut
 with sycamore inlay, made in 317
 hours by Malcolm Clubley, 1973

8 Portrait of Edward Barnsley taken
 in his garden at Froxfield in 1936

Second World War making aircraft and came back full of enthusiasm for
modern methods and machine-tools.

Until the mid-1950s, the isolated workshop had no electricity and the
work was done by hand. Upton began to make changes, however, soon
after his return in 1945. Instead of each man being responsible for inter-
preting Barnsley's design, choosing and cutting the timber, and executing
a piece, Upton took more control upon himself. He also persuaded Barnsley
that some machine tools were essential if they were to compete for the
growth in institutional and business commissions. A circular saw was
installed, then a band-saw, a mortise machine, a planer, and eventually a

spindle moulder, which Barnsley had always regarded as 'the beginning of the end'.[1] He had resisted previously, arguing that the maker gains an extra understanding from direct contact with materials and that important qualities are lost if the finish is too perfect. Change was inevitable, however, and in the 1960s and 1970s the business gained a sounder basis. Barnsley never quite accepted the smoothness of surface achieved by his craft-workers, but if the maker's satisfaction lay in making to the highest possible standards, and if part of the aim of the business was to provide useful and enjoyable work, how could he as designer insist on a rougher finish?

Edward Barnsley still worked at the bench until the early 1970s, but increasingly after the Second World War his place was in the drawing office. To avoid problems while he was away advising at Loughborough, he often produced full-size drawings as well as the eighth-scale designs he had always done. Occasionally a model was also made. Experiments with new methods caused the occasional disastrous failure, but on the whole the quality improved in the post-war period and Barnsley's designs gradually developed away from the Cotswold style towards a lighter mode of his own. Influenced by eighteenth-century furniture, he introduced serpentine shapes, tambour doors, finer inlays, and more delicate handles and fittings. Flat expanses of veneered board gave a lighter appearance and were designed to be more resistant than solid timber to the changes wrought by central heating. New timbers were introduced; as oak went out of fashion and walnut became expensive, padauk, black bean, and mahogany were favoured for their rich effect, which had been missed during the years of austerity.

The increasing elegance of Barnsley's work brought him many corporate and private clients in these years, but he worried about the future of the business after his retirement from Loughborough in 1965. In the event, he was able to say by 1968 that the workshop provided him with an adequate living, but his departure from education was not happy. For nearly thirty years he had travelled regularly to the college to advise on design; contact with young eager minds and with colleagues relieved workshop pressures, such as difficulties over employer–employee relationships, and so retirement was a personal blow. In addition, Barnsley was concerned about the future of craft education in schools; the principles for which he stood appeared to be threatened by 'design and technology' replacing craft teaching.

By the late 1960s, he was also increasingly detached from the world of craft organisations. Upheavals at the Crafts Centre in the early 1960s had prompted him to ally himself with Cyril Wood, a retired arts administrator who wanted to contribute to the crafts. Wood set up the Crafts Council of Great Britain in 1964, at first in conjunction with, but increasingly in opposition to, the Crafts Centre. A series of successful regional exhibitions was organised and he gained support from influential people. By 1965, however, Barnsley had misgivings. He had always told Wood that his organisation should have lay people on its committees, but now he found decisions were made without reference back to makers. He was also alarmed by the costs involved, as Wood was accustomed to working on a grander scale than the founders of the Crafts Centre.

For seven years the Crafts Centre and Crafts Council co-existed, and then the Crafts Advisory Committee was formed in 1971, with greater support from the government. Perhaps inevitably, this new young organisation, dedicated to changing the image of the crafts, did not give much attention to the work of one who had been described as the 'grand old man of Designer Craftsmen'.[2] Barnsley felt increasingly cut off from official recognition.

This was of some concern for his business. For Edward personally, however, there was encouragement from the increasing band of people interested in the work of Gimson and the Barnsleys. Exhibitions at Leicester in 1969 and Cheltenham in 1976 prompted a renewed involvement with the Cotswold style. Several of his cabinets on open stands, of which the Jubilee Cabinet of 1977 is the best known, testify to this influence. The basic form of such pieces, the frequent use of walnut, fielded panels and finely fitted interiors, all reflect the earlier work, though now transformed according to Barnsley's personal style.

As he approached his eightieth year, Edward Barnsley worried about how to secure the future of the workshop, and was persuaded to establish an educational trust to keep the work going and provide workshop training. The first apprentices arrived in 1981. Barnsley's son Jon, an architect, now produces some of the designs and increasingly the trainees are encouraged to design for themselves, within the Barnsley tradition. Edward Barnsley's drawings and photographs remain as a reference source, and his prolific correspondence provides much information for researchers on craft matters.

Barnsley's letters, almost all from the post-war period, reveal a man

continually preoccupied with financial worries and lacking in confidence about his ability to continue designing and sustain his business. They indicate his immense admiration for the work of his cabinetmakers, especially Bert Upton, and his pleasure in the confident approach of George Taylor, but they also show how very difficult he found being an employer. The picture emerging from letters is at odds with that of the charming and vital man remembered by his many friends, and the helpful enthusiast encountered by researchers and fellow craft teachers.

This correspondence has to be balanced, therefore, with other views of Barnsley's character, but it does reveal the major preoccupations of his life. The first was to continue the fine tradition of furniture-making established by his father and Ernest Gimson, and to adapt it to twentieth-century needs. He often regretted not having the wider approach of the architect-designers, but he was like others in this second generation of the Arts and Crafts movement in that he specialised in one craft. He believed the making of fine furniture was of some importance in the modern world, enriching the lives of successive owners through their enjoyment of good work; but even more, he wanted to show that a life spent making things by hand was of value.

Barnsley died in 1987. His work lives on in the Edward Barnsley Educational Trust, in the work of makers trained in his workshop or inspired by his example, and in the many pieces of his furniture cherished by their owners.

Notes

1 Letter from Barnsley to Idris Cleaver, in A. Carruthers, *Edward Barnsley and His Workshop: Arts and Crafts in the Twentieth Century* (Wendlebury, 1992), p. 97.
2 Letter from Barnsley to Idris Cleaver, *Ibid*, p. 140.

Further reading

Carruthers, A., *Edward Barnsley and His Workshop: Arts and Crafts in the Twentieth Century*, Wendlebury 1992.

Carruthers, A. and Greensted, M., *Good Citizen's Furniture: The Arts and Crafts Collections at Cheltenham*, London 1994.

Comino, M., *Gimson and the Barnsleys: 'Wonderful Furniture of a Commonplace Kind'*, London 1980 (reprinted as Greensted, M., Gloucester 1991).

BERNARD LEACH: *rewriting a life*

OLIVER WATSON

Mr Bernard Leach CH CBE died in May at the age of ninety-two. He had greater influence on potting in England than any potter since Josiah Wedgwood in the eighteenth century. If Wedgwood's achievement was to convert a peasant craft into an industry, Leach inspired a renaissance of the craft. Wedgwood forced clay into the unnatural moulds of neo-classicism, Leach insisted that the natural qualities of the clay should be allowed free expression.

THUS *The Times* summed up Bernard Leach's life achievement in its obituary of 19 November 1979. That so powerful an establishment organ should pay him such a fulsome tribute is a direct measure of his success. Leach is the only studio potter yet who has achieved such popular and international renown.

Looking through Leach's life, it is clear that the 1950s was the decade of his greatest achievement, particularly if we stretch it to include the Retrospective Exhibition staged by the Arts Council in 1961. One can plot Leach's success through his extraordinary activity during these years: in what he made, in the founding of his 'school', in his exhibitions and lecturing, and in his writings.

During the 1950s Leach maintained a steady stream of some of his best individual work. This was varied in approach, style and technique. An impressive series of large monumental vases were plain glazed or had incised or painted decoration.[1] Smaller pieces beg a more intimate setting and need to be handled; they are more delicate in both conception and touch.[2] No other decade can compare in the consistency of quality and quantity.

During the same period the Leach Standard Ware was in full production. This useful ware was, in both philosophical and practical terms, the foundation of Leach's practice as a maker: his art was based on the making of humble utility wares, the epitome of true 'potter's work': 'good handmade domestic pots within reach of the ordinary user … low in price but maintaining the liveliness of form and beauty of texture and glaze inherent in good handmade pots'.[3] No other studio pottery was able to match the Leach pottery for the range or the quantity of its output of domestic wares. He also pioneered the use of a mail-order catalogue, of which several issues were produced during the 1950s.[4] In 1950, some sixty items were listed ranging in price from 2s. 1d. for an egg-cup to ten pounds for a tea-set; production neared 20,000 pieces per annum.[5] Demand outstripped production and orders had to be turned away. Its success established the very style that dominated useful-ware potting for decades to come.[6]

In the 1950s the 'Leach school' came into full view. Of pre-war students, Cardew was active in Africa but regularly exhibiting in England. Harry and May Davis were working in Cornwall; Katherine Pleydell-Bouverie was installed in Wiltshire. Both of Leach's sons, David and Michael, left to set up their own potteries. Younger students were also beginning their careers: Richard Batterham in Dorset, Kenneth Quick in Cornwall, Warren MacKenzie in the USA, and John Reeve in Canada.

During the 1950s, Leach's influence was spread abroad through a series of exhibitions and lecture tours. In 1950 an exhibition departed for a three-year, twenty-site tour of the USA, launched by a four-month lecture tour. In 1952, a major conference on the crafts was held at Dartington in which Leach was the dominant figure, and which was in many ways a celebration of the Leach ethic.[7] Leach followed this with a two-year lecture-and-demonstration tour of the USA and Japan. Simultaneously an exhibition toured Britain (Dartington, Edinburgh, London and Birmingham). Further British exhibitions were held in 1957 (Liberty, London) and 1958 (Primavera, London). In 1958 a new exhibition left on a two-year tour of the USA; in 1960, yet another toured the USA, and others were held in London, Sweden and the Netherlands. These were accompanied by a lecture tour in the USA and Scandinavia. In 1961 a major retrospective of Bernard Leach's work was organised by the Arts Council in London.[8] This was followed by a further two-year lecture tour of the USA, Japan, New Zealand and Australia.

Leach's major publication, *A Potter's Book*, was first published in 1940 – quite the worst moment, one might have thought, to publish a book extolling the virtues of an independent self-supporting life in hand-crafted pottery. But in spite of the Second World War and its inevitable restrictions, it was not only published, but also stayed in print. Indeed, it has never been out of print since. A new edition was printed in 1945, a reprint was required again that year, and between then and 1961 it was reprinted no fewer than eight times.[9] This was not the only writing by Leach to appear during the 1950s. In 1950 he wrote an essay in *The Creative Craftsman*, edited by John Farleigh; in 1951 he published *A Potter's Portfolio*, a selection of classic pots with commentaries. In 1952 he published a brief history of the Leach Pottery as a promotional pamphlet, and in 1960 *A Potter in Japan 1952-54*, which mixed accounts of his travels with more general philosophy on art and life. This impressive output ensured that his views and convictions, most eloquently expressed, were readily accessible even to those who did not meet him or hear him lecture.

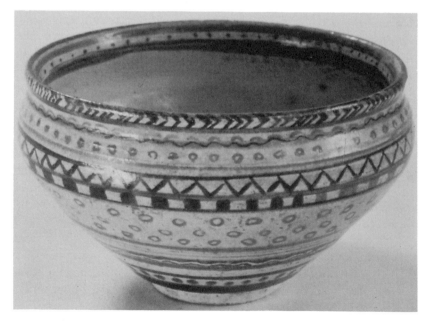

9 Raku ware bowl painted in red and black geometric patterns after archaic Greek vase decoration of the 'geometric' period, 1911

Leach's activity during the 1950s is impressive by any standards, and surpasses that achieved by many during a whole lifetime. It is all the more impressive when one realises that Leach, born in 1887, was already sixty-three in 1950 – an age when many think of retirement.

Such success and far-reaching influence are often explained in terms of his early training in Japan, his absolute belief in the 'great standards', and the strength of his commitment to the Mingei philosophy. When his earlier career is reviewed, however, a different and occasionally surprising picture emerges.

For example, a glance through the earliest pots that he made between 1911 and 1920 in Japan reveal a wide range of sources but the Sung classics are not among them.[10] His earliest dated pot loosely copies a Greek geometric Attic pot.[11] We find Dutch delftwares and English Toft-type slipwares, all these copied in Japanese raku technique.[12] But we see virtually nothing of the classic Chinese stonewares. When he does base his work on Far Eastern prototypes, it is mainly on Chinese blue-and-white porcelain of the late period – a kind that finds almost no echo in his work after his return to England.[13]

Another curious fact in view of his later professed interests is that he paid very little attention to 'traditional' Japanese potteries.[14] Nowhere do we find him setting off to visit them, nowhere a discussion of their wares. When he says that he 'gathered traditional lore from every available source and put it to the test of fire in his own kilns near Tokio'[15] he is referring to the tradition of urban artist-potters like his first teacher Ogata Kenzan VI, not the tradition of country potteries. On his return to England in 1920, there is a similar disinterest in the few remaining country potteries. Apart from a famous visit to Lake's Pottery in Truro, Cornwall, where he and Shoji Hamada learnt to make a pulled handle,[16] Leach had decided that all traditional values had vanished and that tradition needed to be 'consciously rebuilt'.[17] He did not look to see if he could rekindle the last few embers.

Indeed much of Leach's writing up to the 1930s argues not for a return to tradition, but for the role of the individual artist. This is quite contrary to the notion of the anonymous craftsman – an idea that appears to have arrived rather late in his career, and of which he never seemed entirely convinced. He always signed his individual pieces, a practice that raised comment from several quarters, and in 1978 he described the professional

help he received in Japan in 1918-19: 'the trustworthy and experienced potter who managed my workshop and kiln so admirably, demonstrated by his behaviour the right relationship between artist and artisan'.[18] In Japan, Leach the artist appreciated professional help from the artisan.

The same sentiments occur in his writings during his first years in England:

> In Tokio I made shapes and patterns with the same enthusiasm as I spent on drawings and etchings, without thinking at first very much about utility and price. The pots were bought by people who looked, and were accustomed to looking, for the same essential qualities in handicraft as in so-called pure art. By degrees I paid more attention to use, but it was only when I returned to England that I found, as in so many ways, an opposite tendency, a valuation as a matter of course of the utilities first and the spirit second. It was impossible to continue here in so idealistic a condition as to make just what I liked with only kiln and saggars as my limit.[19]

Utility, he appears to be saying, should be of secondary consideration, if of any at all. In a catalogue introduction to Hamada's exhibition in London in 1929 he argues that pottery has emerged from being bound by utility, team-work and tradition, and is now free to express 'individual awareness and responsibility', the difference between ancient and modern work now lying in 'the underlying truth of personal interpretation as against tradition':

> The extension of this well-appreciated fact in the freer arts of painting and sculpture, to the 'individual' or 'artist' craftsmen of our time is quite recent. The public is only just beginning to look critically for a personality behind a pot as it does behind a book. The apparent subjection of utility to beauty by any individual craftsman is deeply repugnant to an industrialized people. But from the craftsman's viewpoint as a workman the matter is otherwise.[20]

Leach the artist-craftsman demands to be judged by the same criteria as any fine artist, categorically rejecting utility as the prime consideration. Similar thoughts are found again later:

> The conclusion we subsequently came to was that making and planning round the individuality of the artist was a necessary step in the evolution of the crafts. So at St Ives, at the outset, we based our economics on the studio and not the country workshop or the factory ... Hamada and I

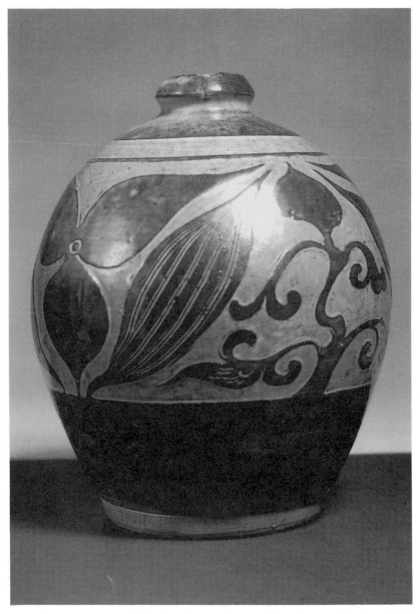

10 Stoneware vase with design of trees; cut grey slip under a milky glaze, 1926

regarded ourselves as being on the same basis as Murray in London, Decoeur in Paris and Tomimoto in Japan ... We worked hard but with irregularity of mood. We destroyed pots, as artists do paintings and drawings, when they exhibited shortcomings to our own eyes (what Hamada called 'tail'). We only turned out 2,000 to 3,000 pots a year between four or five of us, and of these not more than 10 per cent passed muster for shows ... The best pots had to be fairly expensive.[21]

In fact, Leach appears to have started considering the manufacture of tableware seriously as a matter of economic necessity, rather than of philosophic conviction. In 1928 he wrote:

The first daily use pottery I was asked for was invariably a tea-set, but without Eastern teamwork, or our Western machinery, the effort ... is both back- and heart-breaking. Making nothing else, I have calculated that by hard work I and a couple of apprentices could produce some 200 fifteen-piece sets in a year, and that we would have to sell them at about £5 a set to keep going.[22]

This was far from cheap: five pounds then was a very respectable weekly wage.[23]

Leach's main problem during the 1920s was his financial situation. In the early years he had been greatly helped by sales of his work in Japan, and more particularly by his own and his wife's family money, and by the £250 per year for three years offered him to set up in St Ives by Mrs Horne.

In 1923 Mrs Horne's financial support ended, and Leach also lost support from Japan in two ways. First, and most importantly, Hamada and Matsubayashi left St Ives, and this deprived Leach of his essential technical support, as well as artistic comradeship. From the imperfections of many of Leach's stoneware pots in the 1920s it is clear that he was having great difficulty in controlling his kiln or achieving any consistency.[24] Second, the severe earthquake in Tokyo disrupted sales there. In a letter to his uncle-in-law, Dr William Hoyle, Director of the National Museum of Wales, Cardiff, in January 1924 he says: 'the Japanese earthquake has deprived the pottery of a safe £300-500 income and we have but little cash in hand & this year there is my income to meet as well as the usual annual running expenses'.

Leach was finding it difficult to establish a name and a reliable market in the UK. The six-week summer season in St Ives did not provide a suffi-

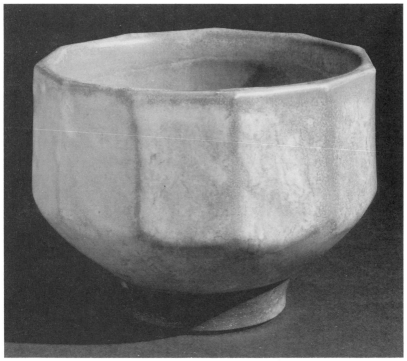

11　Cut-sided stoneware bowl with ash and salt glazes, 1925–26

cient income from holiday-makers. He had regular exhibitions in London, and though they attracted good reviews they did not generate enough profit. In 1925, he was passed over as Professor of Ceramics by the Royal College of Art in London in favour of William Staite Murray. Though he was included in the 1925 Paris International Exhibition, he was not singled out in the official British report but merely listed among other contributing potters 'who showed good work'.[25] Leach was getting desperate, and was seeking ways simply to earn enough money to make ends meet. Towards the end of the 1920s, a series of events helped him reconstruct himself less as artist and more as functional potter.

Realising that expensive individual stonewares were not going to bring financial success, he sought other products without the disadvantages of the complex tea-set. Tiles were his first choice, and one into which

he put a great deal of energy. They were easy to make and they were popular, particularly for fireplaces. They allowed Leach to indulge his preferred and easiest skill – that of drawing. Leach even discovered that blanks from Stoke-on-Trent were cheaper and more reliable than his own.

Most important was a visit in 1929 by Shoji Hamada, the first since he had left England in 1923. He was accompanied by Leach's old friend, the critic and philosopher Yanagi. They were able to discuss with Leach at length for the first time a fully developed Mingei philosophy – where the making of useful wares lay at the foundation of all real art and beauty.[26] The making of useful ware, forced on Leach by economic necessity, thus co-incided with the view forcefully expounded by his greatest friend and mentor, that this was also the most profound way in which to achieve real art.

A third event provided the opportunity for Leach to put these new ideas fully into practice: he met the Elmhirsts of Dartington Hall. Leonard Elmhirst had married Dorothy Whitney Straight, a wealthy American, and together they had embarked on 'an experiment in rural reconstruction'. They formed a community in which education, art and crafts were integrated with the agricultural and forestry work on which the Dartington estate was based.[27] They wanted a potter to join other craftworkers and artists, to teach and participate in the community, and to produce wares for everyday use. Here was the ideal setting for Leach's new start, and one which Yanagi, having met the Elmhirsts, urged on both parties. After negotiations, Leach moved to Dartington in 1932 to set up a workshop, while St Ives was left in the hands of his son David.

However, one final hurdle had to be crossed before the plan could be fully realised. It was soon apparent that Leach would have some difficulty in setting up a workshop to produce a standardised and commercially viable product. He himself later confessed:

> What we have not done at St Ives is to carry the knowledge thus gained [of making pottery] into methods of production which could in a modest way compete with factory quantity and prices. We have not standardised, and we have not organised… By reason of my training and inclination I have approached pottery primarily as an artist and secondarily as a craftsman.[28]

Slater, the manager of the Dartington estate, discussed the matter with Bernard's son, David. Both saw the problem in similar terms.

I do not think that Bernard will ever break with his present tradition apart from David's influence. I had a long talk with David and he agrees with me that he cannot see his father developing the manufacture of household pottery alone. He says he will definitely wish to adhere to his ideas which prevent him making goods which are exact in size or which could be repeated.[29]

David was aware of the technical limitations of his father, and the need for a better organised, more professional approach if they were to make standard ware. A plan was developed in which David would attend the course for pottery managers at the North Staffordshire Technical College. Slater, typically unsympathetic to Leach, wrote enquiring about the possibilities:

we have ... been playing around with a small kiln which is run by an aesthetic potter. I understand that as such a potter he is in the first rank, but unfortunately he is now trying to turn his attention to producing useful articles rather than *objets d'art*...[30]

In 1934, Bernard Leach, funded by the Elmhirsts, undertook his first visit to Japan since leaving in 1920. He gathered material for his book and Mingei crafts for the Elmhirsts and others. While his father was away, David went to Stoke. Bernard was famously furious, fearing that David's standards would be corrupted. David recalls that his father was considerably mollified on his return when he saw the results coming out of the kiln.

On his return to England, Bernard Leach entered into serious discussion with Dartington about transferring the Leach pottery to the estate there. Dartington requested and was provided with a business plan: however utopian, they were commercial realists. Slater replied:

If the commercial section of the pottery is to be developed it must follow upon David's return with scientific knowledge from his training at Stoke ... I am convinced that it is the combination of your knowledge with David's training which is going to enable us to do that which we wish...[31]

Leach was still worried:

Instead [of an industrial approach] I propose a step out from the studio, shall I call it, towards the small factory where quality of design and material is preserved, whilst science and organisation are put at the

service of the artist and craftsman and not prostituted for the sake of easy sales.

He stipulated absolute artistic and technical control for himself, five years to build to profit, and for three years a guaranteed salary of £300 for himself, with £175 each for Harry Davis, David Leach and Laurie Cookes. He still saw tiles as the major earner.[32]

Leach provided a breakdown of the costs, running costs and likely returns, which he feared would not be large. He still clung to the artist's right not to be entirely dictated by commerce:

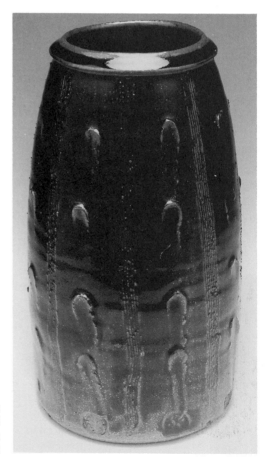

12 Stoneware vase with incised and applied decoration under a tenmoku glaze, about 1960

My own function wherever I work is to bring standards of beauty back into the pots we use, without loss of their suitability for purpose. Utility and beauty can and must be re-united in this as in other crafts. They have been separated so long that the working out of the means may take a ['long' deleted] time. During that period of experiment no one can guarantee large returns. The standards I have in mind are almost unknown in the Potteries but they are those held as the greatest by informed opinion all over the world.

He gave the reasons for the move:

Dartington a very much better site for a pottery; Freight to and from is less; Visitors are fairly constant, here [St Ives] they are limited to six summer weeks; Other potteries in area to connect with in certain ways; Distribution; & lastly capital, which I have not got, is available.[33]

The move of the pottery was imminent, but was held up for a number of possible reasons. Bernard Leach was in the midst of a protracted and painful divorce from his first wife. The political and economic situation in Europe was deteriorating, with fascism in Germany and the prospect of a European war. The Leach pottery did not move from St Ives, but Dartington still supported it, perhaps with an idea of an eventual move. They injected enormous sums: £3,000, the equivalent of ten years' salary for Bernard Leach, was given over three years for the development of a functional stoneware pottery.[34] With this money, David Leach modernised the pottery. He installed the oil-burners for the kiln, the first mechanical pug-mills for mixing the clay, and employed the first local lads as apprentices.[35] In June 1940 David was able to send to Dartington an album of the new Leach Pottery Standard Ware, designed by his father and himself, and made under his direction.

One further stroke of good fortune helped the survival of the Leach pottery. It was allowed to continue to work throughout the duration of the war. In spite of the conscription of key personnel – David Leach in 1941, William Marshall in 1942 – and the partial destruction of the premises by a stray German bomb in 1941, Bernard Leach and sundry others (including the pacifist Patrick Heron, assigned to the pottery by the Ministry) kept the pottery working. They were at a tremendous advantage when the war finished. As regulations relaxed, consumer demand boomed: Heal's, Peter Jones, John Lewis and Liberty's queued up to buy

the Leach Pottery Standard Ware to sell to a country tired of plain white Staffordshire utilityware. Leach's success began at last.

After the war, there appears to have been no further discussion of moving the pottery to Dartington. St Ives developed into the Mecca for studio potters that it is today and Leach assumed his role as the founding father of studio pottery.[36] The decade that followed the war sealed his reputation. On looking deeper into his career, the most impressive feature of his life is the fact that he survived as a potter long enough to reach this successful conclusion. His long and determined struggle pays tribute to his fundamental belief in pottery, whether artistic or functional, as a worthwhile means of expression.

Notes

1 See for example O. Watson, *Studio Pottery* (London, 1993), nos 341 to 347; T. Birks and C. Wingfield Digby, *Bernard Leach, Hamada and their Circle* (Oxford, 1990), nos 8, 15, 29, 58, Sarah Riddick, *Pioneer Studio Pottery; the Milner-White Collection* (London, 1990), nos 74, 75, 78, 82 and 85.

2 Birks and Wingfield Digby, *Bernard Leach, Hamada and their Circle*, nos 17, 21, 23, 31, 32, 36-7, 49-52, etc. George Wingfield Digby suggested to me in 1985 that these intimate pieces were Leach's real achievement.

3 Leach Pottery Standard Ware mail-order pamphlets, 1949 and 1952.

4 The first advertising sheet was issued in 1939. A simple pamphlet with twelve line-drawings was published during the Second World War. In 1946 a sheet of photographic illustrations was included and fifty items were listed. Similar pamphlets were issued regularly throughout the 1950s.

5 'At a net return of three shillings a piece': J. P. Hodin, 'Bernard Leach and His Thirty Years in the Service of Ceramic Art', *The Studio*, 133 (1947), pp. 89–92.

6 In the 1977 edition of *Potters*, the directory of the Craftsmen Potters Association, thirty-seven useful-ware potters work broadly in the Leach style; only twelve do not.

7 M. Coatts, 'The Dartington Conference of 1952' in D. Whiting, ed. *Dartington: Sixty Years of Pottery 1933-1993* (Dartington, 1993), pp. 37–41.

8 Arts Council of Great Britain, *Bernard Leach: Fifty Years a Potter* (London, 1961).

9 B. Leach, *A Potter's Book* (London). First published 1940; 2nd edn 1945; reprinted thirteen times by 1969; paperback 1976, reprinted four times by 1991. Over 100,000 copies have been sold, making it one of the world's best-selling books on ceramics.

10 Ohara Museum of Art, *An Exhibition of the Art of Bernard Leach: His Masterpieces Loaned by British Museums and Collectors* (1980). See also the collections of the Craft Study Centre in Bath, and the University College of Wales, Aberystwyth.

11 Bath Craft Study Collection, no. P75.61.

12 Ohara Museum of Art, *An Exhibition of the Art of Bernard Leach*, nos 5, 10, 11, 13.

13 *Ibid.*, nos 1, 7.

14 Leach was first taken to visit Japanese country potteries by his third wife, Janet, in the 1950s. See B. Moeran, 'Onta and an Aesthetic Standard', *Ceramic Review* (October 1982), pp. 14–17. Onta produced wares in a way unchanged for nearly three centuries. It was 'discovered' by Yanagi only in 1931: Bernard Leach first visited it in 1954.

15 *The Leach Pottery*, St Ives (1928), p. 1.

16 B. Leach, *Hamada, Potter* (London, 1975), Album, p. 3; for existing country potteries see P. C. D. Brears, *The English Country Pottery: Its History and Techniques* (Newton Abbot, 1971).

17 See Brears, *The English Country Pottery*, pp. 168-226. Comparatively few were left after the First World War, however; a dozen were still in serious production when Leach returned in 1920.

18 B. Leach, *Beyond East and West* (London, 1978), pp. 118–19.

19 B. Leach, *A Potter's Outlook* (New Handworkers' Gallery, 1928).

20 B. Leach, *S. Hamada*, exhibition pamphlet (Paterson's Gallery, London, 1929).

21 B. Leach, *The Leach Pottery, 1920-1946* (Berkeley Galleries, London, 1946).

22 Leach, *A Potter's Outlook*.

23 O. Watson, *British Studio Pottery* (Phaidon-Christie's, 1990), p. 23.

24 Many pre-war stoneware pots show firing-cracks, signs of over- or under-firing, bloating, and bubbled glazes. The vase in figure 10 has a bad firing crack across the base; the bowl in figure 11 was accidentally salt-glazed over an ash-glaze. See also letter in K. Pleydell-Bouverie, *A Potter's Life* (Crafts Council, London, 1986), p. 26; and Watson, *British Studio Pottery*, nos. 317 (cratered glaze) and 321.

25 G. Forsyth, 'Pottery', in *Report on the Present Position and Tendencies of the Industrial Arts as Indicated at the International Exhibition* (Department of Overseas Trade, London, 1927).

26 Mingei is not a Japanese tradition, but a creation of Yanagi, much under the influence of the English Arts and Crafts movement. The movement only came into being during the 1920s, after Leach had left Japan. Even the word 'mingei' was new and had to be explained, see Leach, *Hamada, Potter*, pp. 90-1; and

B. Moeran, 'Yanagi, Morris and Popular Art', *Ceramic Review*, 66 (1980), pp. 25–6 and 'Onta and an Aesthetic Standard', *Ceramic Review*, 77 (1982), pp. 14–17.

27 M. Young, *The Elmhirsts of Dartington* (London, 1982).

28 Letter from Leach to Slater, September 1935, Dartington Archive.

29 Note by Slater to Leonard Elmhirst, 20 August 1934.

30 David Leach file, 6 December 1934, Dartington Archive.

31 Arts Applied Leach B1, Bernard Leach letter, 5 September 1934, Dartington Archive.

32 Arts Applied Leach B1, Bernard Leach letter 19 September 1934, Dartington Archive.

33 Arts Applied Leach B1, letter from Bernard Leach to Slater, 21 September 1935, Dartington Archive.

34 Arts Applied, Leach B1, memo of 21 June 1937, Dartington Archive.

35 The first was William Marshall who became foreman before setting up on his own in 1977.

36 O. Watson, *St Ives*, exhibition catalogue (Setagaya Art Museum (in Japanese and English), Tokyo, 1989), pp. 106-7; and Watson, *British Studio Pottery*, pp. 19–21.

<div style="text-align:center">

Facing fundamental things:
EDWARD JOHNSTON and earning a living

</div>

<div style="text-align:center">

COLIN BANKS

</div>

M UCH HAS been written about Edward Johnston's personality and eccentricities: comical stories about his inability to start a project,[1] the initial (and often terminal) slow turning-over in his mind of every aspect of the job.

Noel Rooke, one of his first students and illustrator of his book, *Writing & Illuminating & Lettering* (1994), recalled in a 1945 talk to the Double Crown Club:

> The closeness and intensity of his analysis was past belief. He would think a thing out hour after hour ... until five next morning, for days on end. If and when he had satisfied himself, he would carry out what he had decided on very directly. He did not believe in making any 'roughs' or 'trials' or a 'mock-up' of the same thing to 'see what it looks like' ... The first complete working-out would, if possible, be the final thing ... If he could not be certain that he had found the true answer he would do nothing until he had ... This was the stage which caused clients to wait for years, and often not to get anything at all.

Also well documented is his first exposure to earlier calligraphy, in the British Museum Manuscript Room where from 1898 Sydney Cockerell guided him towards a rediscovery of medieval techniques with the chisel-cut pen.

Then came the inspirational move by W. R. Lethaby that had Johnston teaching at the two-year-old Central School of Arts and Crafts together with J. H. Mason (printing department), Ernest Jackson (lithography), Douglas Cockerell (bookbinding) and May Morris (embroidery). The loyalty of his students there and at Camberwell, and later at the Royal

London County Council
Central School of Arts and Crafts

Whereas in the year 1 8 9 6 the London County
Council founded the Central School of Arts and
Crafts to provide education in the arts and crafts
and industries and to maintain and develop their
practice and Whereas the London County Council
established a Diploma of Fellowship of the School
to be a mark of distinction of past students who by
their practice have promoted the objects of the School
and Whereas the award of this Diploma has
been entrusted by the London County Council
to the Board of Studies of the Central School
We being members of the Board declare that
the Diploma of the London County Council
Central School of Arts and Crafts is hereby
awarded to

13 Central School Certificate with lettering by Edward Johnston

College of Art, is the stuff of legend, but it was not universal. He would
first announce to his class that he would take them through the alphabet
one letter a week. But with long pauses and frequent diversions into the
margins of manuscripts, and in spite of sorely trying the caretakers who
had to wait to lock up, at the conclusion of twelve weeks Johnston's
students would be lucky to have reached the letter D.

In 1906 he published one of the key books about a craft, *Writing &
Illuminating & Lettering*, which is still in print and has been translated into
many languages (strangely, not yet into French). This has been variously
described as 'the best handbook ever written on any subject' (later changed
to a more modest 'masterpiece') while one critic begged the question
'what do you make of a man who says he is going to show you how to
write and then takes ninety pages before you have got a pen to the ink?'.

What is less readily acknowledged is that Johnston was an obses-
sional hobbyist mathematician and this was but one step towards his
compulsion to analyse and quantify perceived truths as he saw them in
lettering and much else.

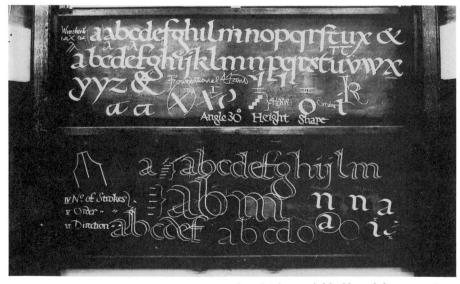

14 Edward Johnston's blackboard demonstrations

He recorded in note form every aspect of his work and his attitudes to his work. These were to have been brought together in a volume of canonic essays in which 'we ought to face fundamental things'. Fifteen years of these labours only saw the light of print twenty-seven years after his death in 1944, after they had been edited by Heather Child and published as *Formal Penmanship* (1971).

The reason for their slow growth is already familiar to us for as he himself says in a letter about these plans for his second book: 'I have this moment composed the following sentence: "He who cuts the nib of a pen to a special shape." And let us hope it is permanently composed because planning to use that remark appears to have taken twelve weeks.' (Child, 1971)

However, in spite of the ball and chain of inertia that he dragged behind him all his life, he developed personal and formal writing hands that were themselves full of incisiveness and vigour, unmatched by anything his disciples were to do. In fact it seemed to me as a student in the early 1950s that his long shadow lay across any further development in calligraphy; he had done, it seemed, all that there was to do, so I put the subject aside in favour of typography. The only lettering I had seen at that time that promised me a way forward was from the Dutch and German typefoundries, and the Stuttgart calligrapher and type designer F. H. Ernst Schneidler (1888-1956). Schneidler believed, as I do, that the best graphic design is rooted in lettering.

It is usually said that German type design has many of its roots in *Writing & Illuminating & Lettering* and it continues to do so;[2] Hermann Zapf has told me how *W & I & L* accompanied him on the first part of his long progress to pre-eminence in today's lettering. But Scottish Johnston was not the only inspiration in the first growth of this German culture. Rudolf von Larisch in Vienna at much the same time as Johnston also taught without much reference to historical models or recourse to the principles of chisel-edge calligraphy lettering. When both were taken together, Germany interpreted the findings in a much more open and progressive way than happened in Britain and the USA.

But then Germany started with a slate clean of Roman lettering, as Gothic had been the national hand there for writing and printing, until Johnston's 'best student' and translator of *W & I & L*, Anna Simonds, returned from London in 1905. The Prussian Ministry of Commerce employed her, on Johnston's recommendation, to show how Latin scripts

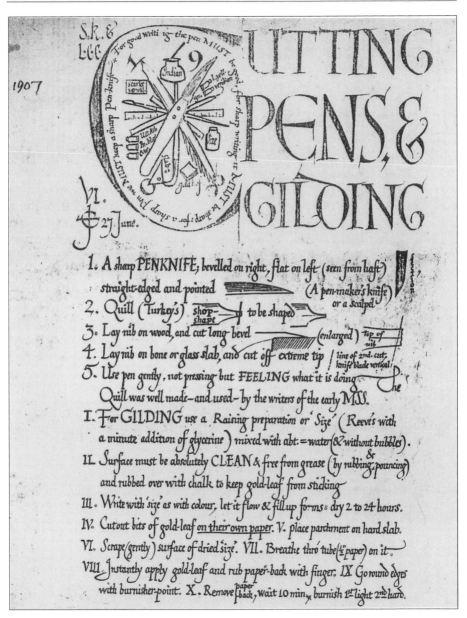

15 Notes on pens and gilding for the Central School of Arts and Crafts classes

were taught in Britain, and then to introduce such systems throughout Germany.

It is Edward Johnston's attitudes towards industry and the way in which these were worked out within the more constrained disciplines of type design that I want to explore now, as they are significant today in the relationship between craft, art and industrial design.

Johnston designed several typefaces, and turned down one for the publisher Burns & Oates by Calvinistically writing to Francis Meynell to the effect that good typefaces existed already so why should we need more. In my view, in spite of his successful and influential Underground Railway Block-Letter and a black letter typeface, and much less satisfactory chancery italic for Harry Graf Kessler's Cranach Press in Berlin, Johnston remained a calligrapher, never a type designer. He regarded, as he should, each letter as a never-to-be-repeated shape related within a flowing pattern of specific words. A piece of metal type that has to be duplicated and recycled again and again within a different pattern of words is another thing altogether, an industrial process both in its inception (type conceived and totally produced by one person has been a rarity) and in its application, as it usually involves compositors, pressmen, finishers and all the complexities of the division of labour.

Johnston wished to have none of industry. In 1932 he wrote to Douglas Cockerell who wanted to propose him for the award of Royal Designer in Industry:

> I regard the RDI as an honour not to be disdained by anyone – let alone by me – and yet, by me, to be conscientiously refused, because 'INDUSTRY' does not appear to be based on good principles or to be aimed at good purpose. In other words I doubt the integrity (and philanthropy) of *typical Industrialism* and regard it as opposed, even actively inimical, to the Arts and Crafts and those who practise them.

About this time he said in his valedictory address as President of the Arts and Crafts Exhibition Society:

> 1st. The Society's proper business is Handicrafts – to make things and to make them well – whatever ultimate use is made of their work.

> 2nd. That now the solid basis of *Use* has been so largely undermined and undercut by mechanical production the Society must consider giving

practical effect to the inimitable and essential value of the Handicrafts in pure education and occupation.

It is such a 'dog in the manger' attitude as this, elevated to philosophical dogma, that has stained much of the relationship between British crafts and industry. It stands in contrast to the understanding of craft as both a separate and an integral force within industry that has been so beneficial in countries like Denmark and Italy.

That the railway alphabet was designed by Johnston is surprising given that he hated industry; he hated industry because it was linked to money, and he was uneasy with design because it was linked to industry and the consequent distancing of the product from its begetter. For him a thing to be well made had to come direct from the hand of the person who conceived it. It was such thinking and Johnston's dilatoriness that led to all the trouble with the Cranach Press italic typeface. Johnston would persist in providing only 'character sketches' plus much criticism from him and Kessler 'for guidance', while the expert punch-cutter, Edward Prince, prayed either to be told exactly what to do or be let alone to get on with it in the way he knew well.[3]

My teacher, Charles Pickering, took the latter course when the Underground Railway Block-Letter medium weight sans typefaces were joined by a bold. Johnston would send the loosest of annotated sketches and Pickering would redraw them. Pickering now comments, sixty years later, 'Johnston was too lazy to draw a complete typeface'.

Be this as it may, Johnston revelled in the derivation of the word 'authentic', from the Greek 'one who does something himself'; I wonder if he knew that 'manufacture', and by extension the industrial 'manu-facturing', comes from 'to make by hand'. Johnston stood four-square for crafts and was opposed to drawing-board design, but it was the squaring of this circle that had to be done in his life-long work for London Transport.

He said in a lecture at Leicester School of Art in 1906: 'I do not see how you can make letters which will make people see them whether they want to or not & no matter where they are, without making them hopelessly loud and intolerable and a public nuisance ...' An answer was already at hand in *W & I & L* where he had written: 'It is quite possible to make a beautiful and characteristic alphabet of equal stroke letters, on the

16 Drawings by Edward Johnston for the Underground Railway Block-Letter,
March 1916

lines of the so-called 'Block Letter' but properly proportioned.' The
proportions he had in mind were those of Roman capital letters from the
cast of the Trajan column in the Victoria and Albert Museum.

Eventually brought to bear on this line of thinking were the consid-
erable personalities of Frank Pick, the London Underground's 'design

manager'; Gerard Meynell, who acted throughout Johnston's long associ-
ation with the Underground as his agent on commission; and Eric Gill,
who received a fee for his initial collaborative work but soon withdrew, no
doubt anticipating difficulties under any such double harness.

In 1916 the first alphabets were in use (advertising as it happens the
Arts and Crafts Exhibition Society's annual show at the Royal Academy of
Arts). At first Johnston's Block-Letters were used as tracing sheets; it is
possible that he had in mind only an interpretation of them by the
draughtsman who copied them on to a lithographic plate. The cutting of
the alphabet into wooden letterpress type was probably done without
much reference to him, and he was later to rail against their transfer from
there via an offset blanket as being far too removed from the original
images. The type was only made in the two weights although Johnston did
a lot of work on a much-used alphabet for bus blinds. Metal types in
smaller sizes than the wooden ones were made in the 1920s, but while
gaining in practicality these have lost in character and were probably only
'waved past him' if he saw them at all.

However, he was responsible for most if not all the London Transport
logotypes, including the famous circle with the transverse bar. Many of his
designs were for special arrangements of words like 'GREEN LINE
COACHES'. He was to have work from London Transport for the rest of his
active life, although his contribution changed from careful and much-
worked-over drawings to the briefest of sketches plus a note to say that the
printer's artist could now see what was required. Paradoxically, London
Transport can be said to have employed Edward Johnston as their first
'industrial design consultant'.

He was, as we would expect, much concerned in the early years with
the spacing of his alphabets, and set out instructions of such complexity
that when I showed them to Walter Tracy, who had spent a lifetime in the
designing of typefaces, Tracy exclaimed, 'Why ever didn't the man go to a
decent typographer!' Curiously, this system is based on the juxtaposition
of one letter shape against another and ignores the space within each letter.

Johnston insisted that, for capital letters, a ratio of less than 1:7 of
thickness of stroke to height impaired legibility, and that 1:5 is as far as it
is prudent to go in making bold alphabets. However, in small and
especially in bold sans serif typefaces, the trick is to model the thickness
of each stroke, be it curved or straight, to carry extra weight but disguise its

unequal disposition. But Johnston would have none of that and was determined on the mathematical principles of even strokes throughout. This put a brake on the development of his alphabet and very nearly saw its demise largely on this account by the 1980s.

He was absolutely right, in my view, when he spoke of a change of size in the same design as being 'absolute not relative'. This was clear when type was cut by hand and its proportions adjusted according to the scale of the letters: computer technology now struggles to recover these important differences in lettering. He also said, 'Nothing is reproduced, something different is produced' in reference to 'the two great modern illusions – Reduction and Reproduction'.

Edward Johnston was much loved by his family and his friends who were both amused by his whimsical and kindly humour (he would dress up a broomstick with a white sheet and play ghosts around Ditchling village on Hallowe'en Night) and impressed by the integrity of his line of thought.

When Johnston submitted his entry in *Who's Who* in 1937, he wrote:

> Studies pen shapes of letters in early mss, British Museum … teacher of the first classes in formal penmanship and lettering … designed block letter based on classical Roman capital proportions (for London Electric Railways).

He was justly proud of squaring the circle of his almost religious beliefs about crafts to the needs of industry. Underground Block-Letter was the typeface from which every twentieth-century sans serif type would then be measured.

Having read his correspondence with London Transport (as the business became), I am impressed by the prompt diligence with which he applied himself to all their requests. It was a courteous, even deferential, and generous postal relationship on their side; producing much that was good for them and kept the wolf, if not always from the door, at least out of Mrs Johnston's larder.

Notes

1 Enid Marx told me of how she walked over the Sussex Downs to call on EJ's daughters shortly after they had all left the same school. Their father was alone

but said the girls would be back very shortly and said, 'do come in and have a cup of tea'. She trailed behind him as he crept around the garden very, very slowly gathering twigs. Equally slowly, he lit a small fire and silently but breathlessly they waited on the reluctant kettle. After about one-and-a-half hours of this they had a cup of tea. Their mutual shyness then dissolved a little and he showed her with great pride the little desk he had built on the first floor. Enid Marx has wondered to this day *how long* that had taken him to make! (This sturdy desk can now be seen in the Ditchling Museum of the Crafts, which has a collection of Johnston's personal and sometimes idiosyncratic artefacts.) Later Enid Marx enrolled in Johnston's class at Camberwell. The first lesson was entirely spent with him going to each student in turn and helping them to cut a quill. With memories of making tea, she left.

2 'The great German typefounding industry, for instance, has been based on a study of the experiments of William Morris, Emery Walker and T. J. Cobden-Sanderson, and the writing of Edward Johnston.' W. R. Lethaby, *Design and Industry* (Design and Industries Association, London, 1915).

3 There is much in Lethaby (1915) to support the wider aims of this paper. His views can be summarised as follows: he considered that design should not be divorced from making; he abhorred 'the denigration of craft skills to the making of bric-a-brac'; his legacy was teamwork activity'; and finally, to paraphrase him, he believed that if we are to redirect today's computer clerks (he said paste and scissors) we will need both art and true craft.

Further reading

Banks, C., *London's Handwriting: The development of Edward Johnston's Underground Railway Block-letter*, London Transport Museum, London, 1994.

Banks, C., 'Edward Johnston and Letter-Spacing', *Matrix*, vol. 15, Whittington Press, Cheltenham, 1995.

Child, H. (ed.) *Formal Penmanship and Other Papers (by Edward Johnston)*, Lund Humphries, London, 1971.

Child, H. Howes, J. (eds) *Edward Johnston, Lessons in Formal Writing*, Lund Humphries, London, 1986.

Dreyfus, J., *Italic Quartet*, Cambridge University Press, Cambridge, 1966.

Howes, J., *Edward Johnston: A Catalogue of the Crafts Study Centre Collection and Archive*, Holburne Museum, Bath, 1987.

Johnston, E., *Writing & Illuminating & Lettering*, 39th impression, A. & C. Black, London, 1994.

Johnston, P., *Edward Johnston*, reprinted by Barrie & Jenkins, London, 1961.

Tributes to Edward Johnston, at a meeting in 1945 of the Society of Scribes & Illuminators. Privately printed at Maidstone College of Art, 1948.

WILLIAM STAITE MURRAY

MALCOLM HASLAM

WITH AN ESSAY on Bernard Leach included in this collection, one on William Staite Murray (1881–1962) might seem redundant. They were of the same generation and their careers as studio potters covered much the same span, although Murray's ended sooner. Both specialised in stoneware, and each based most of his work on the pottery of the Sung Dynasty or its Korean and Japanese derivatives. The two men's pots could sometimes be confused. But a fundamental difference lies between Murray and Leach, a difference that reflects two almost opposing attitudes to the crafts.

Rather than believing, as Leach did, in the potter as a craftsperson working in a spirit of co-operative endeavour to maintain an aesthetic and technical tradition, Murray aspired to be an artist, admittedly drawing from the ceramics of the past, but only in order to make an original and individual contribution to the art of the present. Murray wanted his pottery to be seen and criticised in the context of modern painting and sculpture, and it is this desire that makes him relevant to today's debate about the position of the crafts in modern culture.

The distinction between the opposing attitudes to the crafts adopted by Murray and Leach had become, in the second half of the nineteenth century, a matter not so much of how one should react to the advent of industrialisation, but rather of how society regarded the craftsperson *vis-à-vis* the artist. It was, in effect, a matter of social status. The history of the Arts and Crafts movement in Britain is littered with ex-public school and Oxbridge young men, confident of their position in society, busily bodging chairs, binding books, hammering copper or making things out

of clay – all occupations that were traditionally the preserve of the mechanic or the artisan. To this group belongs William Morris (Marlborough and Oxford), C. R. Ashbee (Wellington and Cambridge) and many others, including Bernard Leach (son of a colonial judge, educated at a Roman Catholic public school). Another character frequently encountered in the annals of the British Arts and Crafts movement is the 'working man', whose life and leisure middle-class reformers hoped to improve through such institutions as the Working Man's College, the government art schools and Toynbee Hall. The 'working man' was quick to grasp the opportunity afforded by artistic training and an introduction to the humanities to raise his social status. If the cachet of the Royal Academician was beyond most, it was nevertheless quite possible to claim the title 'artist', a recognised badge of gentility. An artist in this sense was quite distinct from a craftsperson, although he might, if he wished, design for, or even practise, the crafts; and although he might sell the fruits of his labour in the marketplace, an artist negotiated discreetly and was certainly not a tradesperson. An artist, in short, belonged to the professional classes.

William Staite Murray was the son of a corn and forage merchant in Deptford, London. His father was prosperous, but 'in trade'. The family belonged to a growing segment of Victorian society which George Gissing described, in his 1884 novel *The Unclassed*, a *mélange* of the socially aspiring well-off and the financially straitened gentry. As the young Murray grew up, he would have become aware of the social constraints imposed by a career in trade, and he would have recognised his artistic talent as a means of attaining a loftier position in society. His bent towards pottery, however, rather than serving as a *passe-partout*, might well have blocked his progress. If painting – or even sculpture – was recognised as a profession, the social status of pottery was more difficult to fix. Sir Edmund Elton's baronetcy had lent his activity as a potter an air of aristocratic eccentricity; William De Morgan, who, as the son of a distinguished academic, had an assured social position, had had most of the 'dirty work' (preparing clay, throwing and firing) done for him by hired labourers. The Martin brothers, however, born (like Murray) into the *petite bourgeoisie* of suburban London, had performed all the manual processes of pottery-making themselves, and they had remained at the lowly rank to which they had been born. It quickly became Murray's objective to locate his

work firmly within the realm of 'art', and so gain his admittance to the professional classes.

The scenario of the young Murray seeking social status through an artistic career might remain pure speculation but for a significant clue which can be found in a letter written by the potter many years later. From Africa, where Murray lived from 1939, he carried on a correspondence with L. F. Menzies-Jones, who sent him a copy of George Wingfield Digby's *The Work of the Modern Potter* when it was published in 1952. In his letter of thanks Murray commented on the distinction drawn by the author between the utilitarian character of Leach's pottery and Murray's purely aesthetic approach. 'Pottery as a *trade* and potting as a *profession* are, I think, hardly comparable', wrote Murray. 'The professional,' he continued, 'is one man, an individual, the other is not so. Work by a team of potters cannot be individual; a work of Art is always individual, one does not hear of a team of painters or a team of poets creating a work' (my italics). The use of such socially charged terms to comment on a distinction that Wingfield Digby has presented as purely philosophical, reveals a profound anxiety about class and suggests why Murray persistently affirmed that his pottery was art, on a par with painting and sculpture.

Murray always tried to ensure that his thoughts and actions were those of an artist. Even his appearance he monitored. He was photographed in the 1920s wearing a smock and floppy bow-tie which had become over the years the artist's typical attire; not for Murray the working man's blue blouse, worn with pride by William Morris and Cobden-Sanderson. Although he belonged to the Art Workers' Guild, he was much more active in the affairs of the Seven and Five Society, a group of avant-garde painters and sculptors to which he was elected in 1927. He regularly attended meetings of the Society; in 1931 he was elected to the hanging committee and in 1934 made honorary treasurer.

A further example of Murray's pursuit of equal status with painters and sculptors is provided by his choice of where he exhibited his pottery, and with whom. In 1924, he showed his work alongside paintings by Cedric Morris. He participated in every Seven and Five Society exhibition from 1928 until its fourteenth and last show in 1935. His stoneware shared an exhibition at the Beaux Arts Gallery in 1927 with paintings by Ben Nicholson and Christopher Wood, and the following year he showed with Ben and Winifred Nicholson at the Lefèvre Galleries. In 1931, his

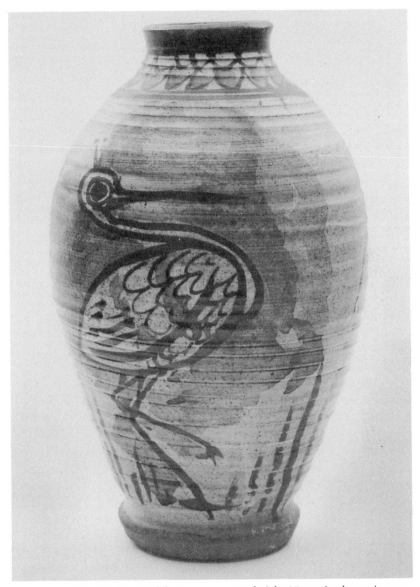

17 'Wading Birds', stoneware vase, height 27 cm. Its decoration was influenced by the bird paintings of Cedric Morris, with whom Murray shared an exhibition in 1924, and who once owned this vase

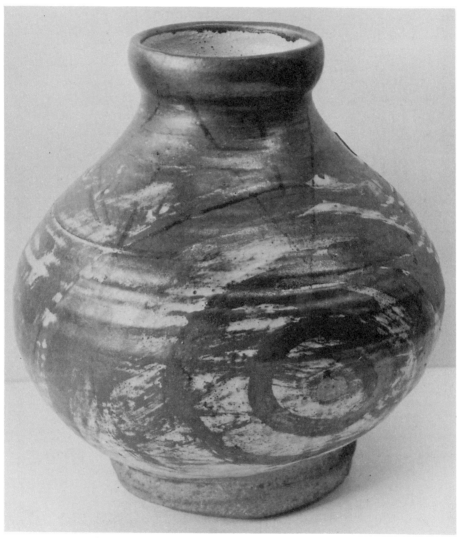

18 'Sonata', stoneware vase, height 24 cm, 1937–39. The abstract decoration reflects Murray's membership of the Seven and Five Society, which eventually banned representational work from its exhibitions

work was shown at the Bloomsbury Gallery with sculpture by Barbara Hepworth and paintings by Ben Nicholson again. Between 1924 and 1929 he was given annual one-man exhibitions at Paterson's Gallery, a venue more usually associated with Old Master paintings; from 1930 he switched his annual show to the more prestigious Lefèvre Galleries, then an important arena of British and European avant-garde painting and sculpture. His participation in shows organised by the Red Rose Guild and the Arts and Crafts Exhibition Society was far more perfunctory and of little commercial significance.

The prices Murray asked (and was paid) for his stoneware were astronomical, much more on the plane of painting and sculpture than pottery. For his biggest and best pieces, he regularly charged sums equivalent, at today's values, to thousands of pounds. Even during the Depression of the early 1930s, Murray was demanding 160 guineas for one particular vase. 'In his enthusiasm for form and colour in the abstract,' wrote Charles Marriott in *The Times*, 'he has lately been in some danger of forgetting that a pot is after all a pot.' The 160-guinea pot was called 'Song of Songs'; Murray's practice of giving his works titles was yet another stratagem in his campaign to win for his pottery the kudos of painting or sculpture. Many of the titles alluded to music, for example 'Diapason', 'Spring Song', 'Fire Music', 'Nocturne'. The last name reminds one of Whistler's paintings, and some of the other titles that Murray gave his pots, such as 'Rose-Verte', 'Brown Study' or 'Moonlight Blue', evoke memories of the Aesthetic Movement, when artists had been demi-gods and questions of artistic taste had almost as much *gravitas* as any matter of social discrimination.

It must have been a considerable fillip to Murray's social aspirations when he was appointed head of the pottery department at the Royal College of Art in 1926, a post he attained only after some quite abrasive jockeying with Bernard Leach. The significance of the appointment to Murray is indicated by his reaction on hearing of the efforts made by his successor (Professor H. W. Baker) to forge links between the department and industry: 'Why,' he asked scornfully, in a letter to Menzies-Jones, 'call it the Royal College of *Art*?'

In order to have his pottery recognised as commensurable with painting and sculpture, Murray constructed his own artistic programme based on current aesthetic theories. He maintained the importance of pottery as a medium which combined the formal values of sculpture with

painting's use of colour, and he took every available opportunity to deliver this message. In 1924, he wrote a short article for the *Arts League of Service Bulletin* entitled 'Pottery and the Essentials of Art',[1] and the following year, a longer piece by him, 'Pottery from the Artist's Point of View', appeared in the magazine *Artwork*.[2] But Murray was no intellectual, and neither article shows any very cogent reasoning or much clarity of expression. The best way that he found to communicate with his public was through the critics. He used to buttonhole them at the private views of his exhibitions with the importunity of an Ancient Mariner and then expatiate on art, pottery and Eastern religion. Charles Marriott, H. S. Ede and Herbert Read were among the more revered spokesmen whom Murray persuaded to utter his theories. 'Pottery ... is a link between painting and sculpture', Murray had asserted in his 1925 article for *Artwork*, and Ede, writing about Murray's work in the same journal three years later, endorsed that view: 'Pottery is midway between painting and sculpture'.[3] In 1930, Read, writing in *The Listener*, acclaimed the success of Murray's propaganda, at the same time contributing to it himself: 'Mr Murray's pottery ... has now for several years been making its way into public consciousness, and even the critics have been compelled to consider it, not as pottery, but as art'.[4]

William Staite Murray shared with Bernard Leach an intense interest in oriental religions, but in Murray's case the obsession was fuelled by the relevance of Eastern mysticism to modern art. Leach came to Lao-tzu, Confucius and Buddhism through his friends in China and Japan, whereas Murray encountered them in the pages of Western art magazines. It was apparently in 1909 that Murray first showed an interest in practical pottery, when he attended classes at the Camberwell School of Arts and Crafts, and in February of that year *The Studio* included a long article on the pottery of the Japanese tea ceremony, written by the editor, Charles Holme.[5] Several of the illustrations showed pieces that were quite closely imitated by Murray when he started making stoneware some ten years later, and the text, too, held significance for Murray's future. For, in this article, Holme introduced the English art world to the idea that an artistic philosophy relevant to the present day could be deduced from the Tao, the sixth-century BC teachings of the Chinese philosopher, Lao-tzu:

> The teaching of Laotze, a contemporary of Confucius, and the influence of Zenism – a branch of Buddhism in which is incorporated much of the

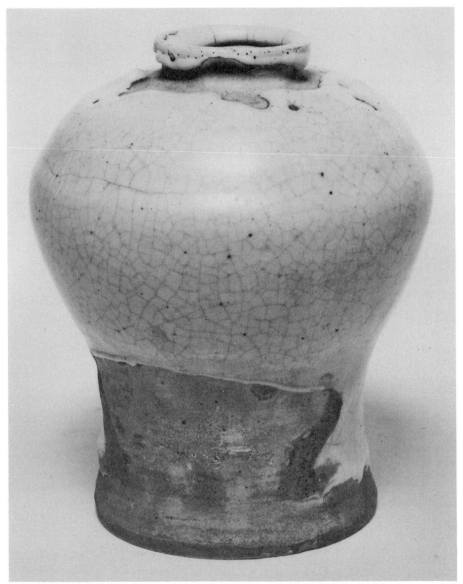

19 Stoneware vase, height 15 cm, *c.* 1922. Murray admired the pottery used in the Japanese tea ceremony and the Sung wares from which it was derived. His early stoneware suggests this enthusiasm and shows how quickly he acquired a technical proficiency

20 'Standing Buddha', stoneware vase, height
105 cm, *c.* 1938 (present whereabouts
unknown). Towards the end of the 1930s
Murray made several tall, slim vases of great
power and beauty (two of them are in the York
City Art Gallery). They are the culmination of
Murray's attempt to fuse Eastern mysticism with
elements of modern painting and sculpture

spirit of the Laotze philosophy – are largely responsible for the charac-
teristics which signalise every detail of the tea-ceremony.[6]

But Holme did not restrict the influence of Lao-tzu's philosophy to the
rites and paraphernalia of the tea ceremony. He goes on to describe its
effect on thirteenth-century Japanese culture in general:

> Laws of art were derived from a close study of the life of nature, and an
> intimate sympathy with it in all its phases. The ideals of the painter and
> poet were filled with Romanticism in its purest and most elevating form
> – in its exaltation of spirit above mere naturalism.[7]

The implication that pottery might obey the same 'laws of art' that
govern poetry and painting surely enhanced the status of the potter, and
Murray would have been delighted to read Holme's concluding
paragraph:

> The pottery of the Cha-no-yu is among things Japanese the most to be
> cherished, because it affords supreme evidence that the pure Spirit of Art
> may enter into and render precious the most humble of man's creations.[8]

Murray told Menzies-Jones in a letter written from Africa in 1942 that 'the
Chinese point of view based on Tao, either in philosophy or in Art, which
is fundamentally the same view, has always made a direct appeal to me'.

Holme's phrase 'exaltation of spirit above mere naturalism' is the key
to understanding the significance of oriental art to the modern movement
in Britain. It provided a precedent for the non-representational styles of
painting and sculpture which some avant-garde artists were exploring. The
magazine *Rhythm*, which was published from 1911 to 1913, served as the
house-organ of a group of young artists and critics which included J. D.
Fergusson, Henri Gaudier-Brzeska, Laurence Binyon, John Middleton
Murry and Michael Sadler. In the spring 1912 issue, Binyon wrote:

> How single of aim appear the great masters of China and Japan compared
> with us, who wrestle with complexities, entangled in the accidents of
> matter, and who are always invoking for art the irrelevant authority of
> science … The secret of this art is all in the paradoxes of Lao-tzu and in
> his doctrine of the Tao.[9]

Murray was probably on the fringes, at least, of the *Rhythm* circle. In
1919 he showed his pottery at an exhibition organised by the Arts League

of Service, a body which had been founded by some of the *habitués* at the Margaret Morris School of Dance in Flood Street, Chelsea. The lifelong relationship between Margaret Morris and J. D. Fergusson, co-founder of *Rhythm* and its first art director, was beginning at this time, and many of the magazine's contributors attended the weekly meetings of a club which Morris had started at her school. This would have been an ambience that Murray would have relished, thronged as it was by painters and sculptors such as Augustus John, Wyndham Lewis and Jacob Epstein. Further evidence that Murray belonged to this coterie is provided by his collaboration with the Vorticist painter Cuthbert Hamilton (together they formed the Yeoman Potters from about 1915 to 1919), and by the prominence that *Rhythm* gave to the philosophy of Henri Bergson, an abiding enthusiasm of Murray's.

'It was, I think,' Murray divulged to Muriel Rose in a letter of 1951, 'an insight into potting as a fundamental abstract art that led me to take up pottery-making.' Murray perceived that in pottery lay a solution to the problems of non-representational art, which were troubling several painters and sculptors in the wake of Roger Fry's Post-Impressionist exhibitions of 1910 and 1912. In the same Spring 1912 issue of *Rhythm* that carried Binyon's comments on Chinese and Japanese arts, was an article, written by Michael Sadler, entitled 'After Gauguin'.[10] Sadler, whose translation into English – the first – of Kandinsky's manifesto of abstract painting, *Über das Geistige in der Kunst* (*Concerning the Spiritual in Art*), would be published two years later, pointed out that Gauguin's followers were moving inexorably towards abstraction, and he instanced the pottery decorated by André Derain. Murray might well have regarded this as his cue, and his earliest work, made at the Yeoman's Row pottery he shared with Cuthbert Hamilton, was faience painted with abstract or semi-abstract designs. In his 1924 article, he asserted: '[Pottery] is an admitted medium for the expression of abstractions in form, colour and design. Abstract designs, challenged in drawings and paintings, are accepted in Pottery'.[11]

A glimpse of Murray's social ambition in the raw is offered by comments he made about the Japanese artist Koetsu, who included painting and pottery among his many activities. Murray was probably aware of the high praise bestowed on Koetsu by Ernest Fenollosa, the American art historian whose *Epochs of Chinese and Japanese Art* was

published posthumously in 1912; the book had been edited by the poet Ezra Pound, an ally of the Vorticists and a regular at the Margaret Morris School of Dance. Fenollosa had written of Koetsu's 'magnificent orchestrations of line and colour, which only suck up as much of natural suggestion as they care to hold' and 'show for the first time what art of the future must become'.[12] It is not surprising that the Vorticists had included Koetsu among the 'Blessed' in the second issue of their magazine *Blast*, published in 1915. Murray probably saw an article on Koetsu written by the poet Yone Noguchi which had appeared in *Rhythm*; Noguchi described how Koetsu had been presented by a prince of Yedo with 'a piece of land, then a mere waste'.[13] When Murray himself came to write about Koetsu, he put a different slant on the gift: 'The foremost of Japanese artist potters was Koetsu, who ... was ennobled and presented with a whole village by the Crown for his services to art'.[14] The preceding sentence helps to confirm that Murray's thoughts were more on English social rank in the early twentieth century than oriental pottery of the past: 'In the East', he wrote, ... 'many painters practised also the art of potting, not merely decorating but working as potters'.

The American writer Edward Bellamy, in his utopian novel *Looking Backward: 2000-1887*, published in 1888, describes society in the year 2000, when everybody chooses the occupation that suits them best. He contrasts this with the position of his own generation:

> The vast majority of my contemporaries, though nominally free to do so, never really chose their occupations at all, but were forced by circumstances into work for which they were relatively inefficient, because not naturally fitted for it ... [The] well-to-do, although they could command education and opportunity, were scarcely less hampered by social prejudice, which forbade them to pursue manual avocations, even when adapted to them, and destined them, whether fit or unfit, to the professions, thus wasting many an excellent handicraftsman ... All these things are now changed. Equal education and opportunity must needs bring to light whatever aptitudes a man has, and neither social prejudice nor mercenary considerations hamper him in the choice of his life work.[15]

Murray showed great resolution when he chose to be a working potter, and he overcame obstacles to his social ambition by insisting that he was an artist, not an artisan. His achievement contributed to the

destruction of those obstacles, and helped to prevent the waste of talent that Bellamy regretted. As for the 'equal education and opportunity' that Bellamy foresaw, we have less than five years to go before the year 2000.

Notes

1 *Arts League of Service Bulletin 1923–24*, p. 11.

2 *Artwork*, 1: 4 (May-August 1925), pp. 201–5.

3 H. S. Ede, 'Ben Nicholson, Winifred Nicholson and William Staite Murray', *Artwork*, 4:16 (Winter 1928), p. 267.

4 Herbert Read, 'Weekly Notes on Art: Art and Decoration', *The Listener* (7 May 1930), p. 805.

5 Charles Holme, 'The Cha-no-yu Pottery of Japan', *The Studio*, 46 (February 1909), pp. 29–45.

6 *Ibid.* p. 32.

7 *Ibid.*

8 *Ibid.* p. 45.

9 Laurence Binyon, 'The Return of Poetry', *Rhythm*, 1: 4 (Spring 1912), p. 2.

10 Michael T. H. Sadler, 'After Gauguin', *Rhythm*, 1: 4 (Spring 1912), pp. 23–9.

11 *Arts League of Service Bulletin*, p. 11.

12 E. F. Fenollosa, *Epochs of Chinese and Japanese Art*, vol. 2 (London, Heinemann, 1912), p. 128.

13 Y. Noguchi, 'Koyetsu' [*sic*], *Rhythm*, 3: 11 (December 1912), p. 304.

14 *Artwork*, p. 201.

15 Edward Bellamy, *Looking Backward: 2000–1887* (London: Newnes, n.d.), p. 65.

<div style="text-align:center">

PHYLLIS BARRON
and DOROTHY LARCHER

</div>

<div style="text-align:center">

BARLEY ROSCOE

</div>

TODAY the hand-block printed textiles of Phyllis Barron (1890–1964) and Dorothy Larcher (1884–1952) remain as unique and inspiring as when they were first printed in the 1920s and 1930s. These textiles are noted for the assurance and originality of the designs, their distinctive and subtle colouring, and the quality of the materials selected to print on. Despite the peculiarly English feel of these textiles, they were in complete contrast to what was generally being produced in Britain in the inter-war years for dress and upholstery. They stand apart, even when compared to the few other well-established contemporary hand-block printed textiles that were available, such as those of Alec Walker for Crysede or Joyce Clissold at Footprints, where designs were often on a smaller scale and the results frequently busier and more fragmented, often employing more colours.

Both women had studied painting at art school before the First World War – Barron at the Slade School of Art under Tonks and Steer, and Larcher at Hornsey School of Art, where she later taught. Their training as artists stood them in good stead as textile designers and both had a flair and ability for devising designs in repeat. Barron tended towards strong geometrical patterns while Larcher often based designs on plant and flower motifs. The size of the blocks would vary according to their intended use. A small overall geometric motif such as 'Belge', or a floral design like 'Little Flower' were both meant for dress rather than uphol- stery, as seen in a beautiful grey silk-velvet evening-jacket and long, brocade silk dress. In contrast, the block for the central motif in 'Basket' measured almost 10″ × 8″ and clearly was a design intended for

furnishing. It was only the third block Larcher had cut but it remained a popular design for curtaining right through the 1930s, most often seen in black, brown or beige, printed on a natural linen or heavy cotton. Equally, some designs like 'Peach' were as happy printed on velvet for a smart jacket and skirt, or printed on linen to make an elegant covering for a sofa or chaise longue. Materials on which Barron and Larcher printed also included organdie for summer curtains, as well as fine cotton for dress, and crêpe de Chine, georgette and Rodier wool for scarves and stoles. Over the years their palette broadened, but always retained a preference for blue, black, brown or rust – the colours first achieved from early experiments.

Barron had first been inspired to find out about the hand-block printing of textiles in her mid-teens whilst on a sketching holiday in Normandy with her elder sister. Their tutor, Fred Mayor, had found some old printing blocks in a junk shop and let Barron experiment with them. Her first disastrous attempts involved using oil paints on paper, but when the pins in the blocks tore the paper she realised that they must have been used for the printing of textiles. Barron tried to find out more but was unable to get information from the Slade or other art schools. However, she found two invaluable books in the library of the Victoria and Albert Museum: *Experimental Researches Concerning the Philosophy of Permanent Colours and the Best Means of Producing Them by Dyeing, Calico Printing etc* by Edward Bancroft (1794), which she devoured like a novel, and *A Practical Handbook of Dyeing and Calico Printing* by William Crookes (1874). The Patent Office was also another useful source, as before a dye can be patented a full description of ingredients and processes has to be given.

Encouraged by her reading, Barron began to experiment enthusiastically using the French blocks. Through a chance conversation with a friend she discovered that by printing on indigo-dyed cotton with nitric acid, the dye was discharged (bleached out) and the design of the block appeared in white on the dark-blue ground. Initial attempts to make her own indigo vat were thwarted, but she persevered and later she was to describe indigo as the 'greatest thrill' of her printing life. She added cutch to her repertoire which gave her a brown, and by printing with pyrolignite of iron on wartime balloon-cotton, or grey linen prison sheeting steeped in powdered oak galls, she achieved black. In 1915 she cut her first block, 'Log', basing the design on the graining of the wood she was cutting, and spent many hours trying to get the pattern to repeat. She also learnt how

21 'Elizabethan', designed by Phyllis Barron for the coming-out dance
of the Duke of Westminster's daughter, 1925

to make a steamer using a dustbin and gas ring, after hearing a lecture given by G. P. Baker, owner of the printing firm at Crayford in Essex, which enabled her to fix the dyes permanently and extend her range further. The publication of *A Book on Vegetable Dyes* by Ethel Mairet in 1916 not only started Barron experimenting with rust (ferrous acetate), but prompted her to write to Mrs Mairet enclosing samples of her work for comment. Ethel Mairet was most enthusiastic, urging Barron to exhibit and sell her work. The following year Barron had her first exhibition and subsequently went on to show her printed textiles at several exhibitions at the Brook Street Gallery alongside weaving from Ethel Mairet's workshop.

At one of these she was discovered by Mrs Detmar Blow, wife of the architect then engaged in work for the Duke of Westminster. As a result Barron was commissioned to print all the textiles for the Duke's Elizabethan-style yacht *The Flying Cloud*. This was a major undertaking as there were 'forty cabins each with divans, bunks and curtains, and an enormous saloon in the middle', so the yardage of printed material required was much greater than anything she had attempted before and the job took three months to complete, even with extra help. Other commissions received from the Duke included refurbishing his estate offices in Davies Street for his daughter's 'coming-out' dance and printing the textiles for his hunting lodge in Bordeaux. For the former Barron recalled:

> We printed black and white curtains in the 'Elizabethan' design for three enormous windows, with broad buffy braid and red cording all down them … and two or three dozen enormous cushions of exquisite Chinese silk dyed with madder with red and white fringes – they looked really lovely. The idea was that all the dancers would sit on the floor. I don't know whether they did for though I was invited to the dance I was much too tired to go.

Dorothy Larcher had joined Barron in 1923, having recently returned to England from India where she had accompanied Lady Herringham to help make a record of the Buddhist frescoes in the Ajanta caves, and later taught and lived with an Indian family in Calcutta because the war prevented her coming back to England. On her return Larcher was introduced to Barron's work by a mutual friend, the embroideress Eve Simmonds, and subsequently joined Barron's workshop in Hampstead High Street. Soon afterwards they moved to 2 Parkhill Studios in Parkhill

Road and shared a flat together which was practically next door, remaining there until they moved to the Cotswolds in 1930. As their reputation grew more established, orders from private clients increased and the workshop expanded. They took on two girl school-leavers to help with the printing and in 1925 were joined by Enid Marx. Marx had just left the Royal College of Art and subsequently went on to set up her own workshop. Certainly it was hard work as part of the team and often the arduous tasks of preparing the cloth and the dye-mixing, dyeing, steaming, washing and ironing seemed to leave little time for the designing, block-cutting and printing; yet by now a new design needed to be produced almost every fortnight .

An exhibition at the Mayor Gallery in 1926 received an enthusiastic review from Roger Fry in *Vogue* (April 1926). Previously Barron had exhibited in early displays of the Omega Workshops but had declined Fry's suggestion to join the group, preferring to retain her independence. Dorothy Hutton showed Barron and Larcher's textiles at The Three Shields Gallery, and later The Little Gallery and The New Handworkers Gallery both kept a range of their textiles in stock and were their main London sales outlets after Barron and Larcher moved to Gloucestershire.

Wanting more space in which to work and show their materials, Barron and Larcher had been keen to move out of London for some time. The Cotswolds seemed a natural choice since they already had friends living there and liked the area. Since Barron came from a wealthy family she was fortunate to have financial independence from the workshop and they found a lovely eighteenth-century property to buy, Hambutts House on the edge of Painswick village. This seemed to answer all their needs, having a separate stable block which they converted into a spacious workshop, complete with sunken indigo vat. The printing room was on the floor above, which they equipped with several long print tables. The garden on both sides of the lane running in front of the house was a bonus that they both enjoyed and Barron tended it with special care. Certainly it proved a rich source both for Larcher's textile designs and, later, her flower paintings. Subsequently it was to leave a lasting impression on Susan Bosence and influence her own textiles. She recalled:

> I used to just devour every sight of her [Barron's] garden ... she had a most exquisite collection of beautiful flowers, plants ... the ones that

touched me most were the very delicate ones with fine, fine lines – starting fine and then just going off into nothingness, and wonderful little spots in exactly the right place, and all this, you know, I absorbed and I couldn't stop thinking about them and I think it came through in my work.

The 1930s were years of expansion. Barron and Larcher had arrived in Painswick 'thirsting for more colours' and immediately began experimenting with new dyes, as well as developing overprinting, in contrast to the 1920s when economic constraints had often meant they kept to single-colour prints. Local water was especially good for dyeing madder, and staff from the West of England Cloth Mills in nearby Stroud proved very helpful, allowing them to experiment with some of the dyes they were exporting. Similarly, when Barron and Larcher had been working in Hampstead, Bard & Wishart had been equally supportive, sending repre-

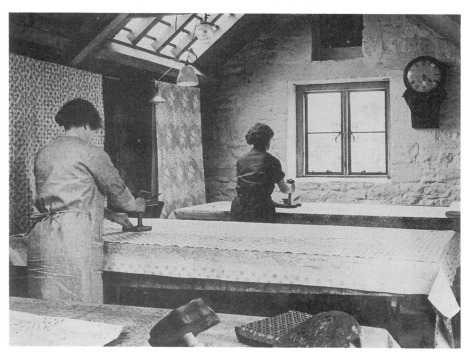

22 Peggy Birt and Daisy Ryland hand-block printing lengths in the workshop at Hambutts House, Painswick, 1936

sentatives round to advise on the use of new chrome colours.

Local help was used in the workshop: Peggy Birt to help with the printing, sometimes assisted by Daisy Ryland who could also sew very well. She would hem scarves and make up the smaller items while Emily Edsall was responsible for making up curtaining and upholstery. Dorothy Larcher trained the assistants and supervised the printing, while Phyllis Barron ran the administrative side of the business and was in charge of the

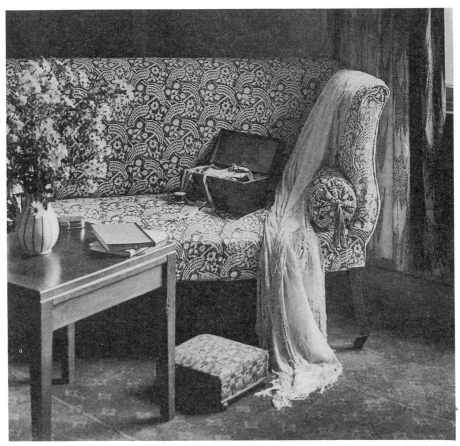

23 Sofa upholstered in 'Peach', probably printed on linen. This design, named after Harry Peach of Dryad Handicrafts, existed in several variations and was used for furnishings and dress

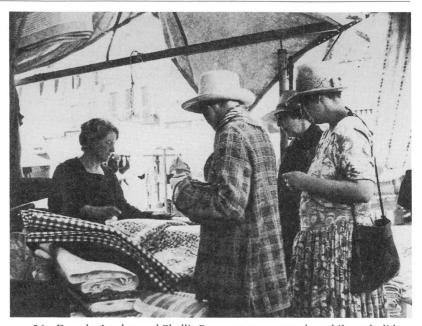

24 Dorothy Larcher and Phyllis Barron at a street market while on holiday
in France about 1930. They are both wearing garments made from their own
hand-block-printed materials

dye-mixing. Both women designed and cut blocks which were made of
mahogany sawn to size using a template supplied by the local builder. The
designs were either cut directly into the wood or, more often, cut in lino
which was then mounted on wood. Blocks were used very creatively to
achieve rich and unusual effects; for example, they might print a block
such as 'Guinea' by placing it first one way on the material and then
overprint with the block reversed. Sometimes, if a single-colour print was
not successful, the cloth might be resuscitated by overprinting with a
completely different design, perhaps using one of their old French or
Russian blocks. Surprisingly, some household items also proved useful
tools, such as a nailbrush for spotting or a pastry cutter for printing a fine
zigzag, as seen in 'Gordon' where a length of cream crêpe de Chine was
printed in grey, but embellished by use of the pastry cutter and a small V
printed in a subtle mauve.

Their order book for 1938–45 and surviving exhibition catalogues

show prices for lengths varied from several shillings per yard to a few pounds according to the number of colours and type of material used. So in the late 1930s a single-colour print on linen might fetch 12s. 6d. (£0.63 at 1997 rates) a yard while a fine velvet could be as much as £2.15s. (£2.75). Two important commissions received were for indigo-dyed linen curtains for the choir stalls in Winchester Cathedral, and an impressive range of their designs for curtaining and upholstery for new buildings at Girton College, Cambridge. Designs took their names from a variety of sources. Sometimes they came from the commission as in the case of 'Winchester', 'Girton' and 'Peach', named after Harry Peach of Dryad's. Alternatively, it was because of an easily identifiable motif, such as 'Basket' showing the subject filled with flowers and fruit, or 'Holly' where a single leaf makes a distinctive repeat. 'Motor' seems a less obvious title for a series of very fine zigzags in black on white linen, but apparently the block was made from a rubber car mat!

Special exhibitions were held in the summer at Hambutts House but visitors were welcome throughout the year and encouraged to watch printing and dyeing in progress. Muriel Rose who ran The Little Gallery not only kept a selection of their materials in stock on a sale-or-return basis, taking a 33 per cent commission, but also had sample books available for customers to chose from and place orders. She was a good friend and did much to promote their work. Throughout the 1930s she regularly held special displays of their textiles. These were sometimes held leading up to Christmas or alternatively 'in the month of May', when customers would be introduced to new designs for summer dresses and furnishing. Sometimes examples from Barron and Larcher's collection of historic printed textiles were also shown, many of which they had purchased quite cheaply whilst on holiday in France. These exhibitions were often visited by Charles Marriott and his supportive and favourable reviews would appear in *The Times*. Throughout the 1930s they also took a stand fairly regularly at the annual autumn exhibitions of the Red Rose Guild in Manchester, and nearer to home showed with the Gloucestershire Guild of Craftsmen, which had been formed in 1933.

The outbreak of the Second World War marked the end of an era for the workshop. Materials were in short supply, The Little Gallery had been forced to close, there was no longer a London sales outlet, nor was there the same demand for their work any more. Subsequently they sold

Hambutts House, using the money to convert their workshop buildings into a smaller but characterful home which they named Hambutts. This was a period of long illness for Dorothy Larcher but she now focused on flower painting, with Barron bringing her her favourite blooms from the garden. These Larcher would carefully arrange into distinctive compositions, completing some forty paintings before her death in 1952.

Meanwhile Barron turned to local government, taking a leading part in the life of Painswick and immersing herself in a wide range of local projects. After Larcher's death, which Barron felt very keenly, she became increasingly interested in education and could not have been more generous in sharing her expertise with others. Susan Bosence has fully acknowledged the part Barron played in encouraging her when she was just starting to find out about printing and dyeing. Not only did Barron show her how to make an indigo vat and discuss recipes and samples, but became a close friend and seemed both pleased and relieved to be able to pass on her knowledge. In the 1950s Barron also made regular visits to help with classes at Stroud School of Art, of which she was a governor, and between 1960 and 1964 she contributed to the Ministry of Education Courses that Robin Tanner ran at Dartington Hall for primary and secondary school teachers. Both Robin and his wife Heather were very supportive friends and Barron joined them on holidays in France. Latterly they enjoyed discussing the format for two huge volumes that Robin Tanner planned to compile in duplicate as a complete record of Barron and Larcher's work. Sadly he had only just started work on the first volume when Barron died suddenly in November 1964 following a severe bout of influenza.

In her will, Phyllis Barron left her work to the Tanners and over the next three years three memorial exhibitions followed in Painswick, Bristol and Cheltenham. Consequently, many people felt a permanent home should be found for these textiles and this encouraged a group of craftspeople and educationists to form the Crafts Study Centre Charitable Trust. Their purpose was not just to find a base to show Barron and Larcher's work but to form a collection and archive of work by leading British artist-craftspeople of the twentieth century in textiles, ceramics, calligraphy, lettering and wood. Thanks to the partnership with the Trustees of the Holburne Museum and the University of Bath, the Crafts Study Centre opened in Bath, within the museum, in 1977 and is now the place in which the largest collection of Barron and Larcher's work may be seen.

DAVID PYE

PETER DORMER

David Pye is the intellectual leader of twentieth-century British crafts. His terse writing is questioning and unsentimental. This woodworker, designer and writer was born in 1914 and died on 1 January 1993. He was Professor of Furniture Design at the Royal College of Art from 1964 to 1974. He is famous for his carved bowls and turned boxes and for three books: *The Nature of Design* (1964), *The Nature and Art of Workmanship* (1968) and *The Nature and Aesthetics of Design* (1978).[1]

THIS BRIEF ESSAY discusses Pye's writing, not his craft. This emphasis might seem perverse; after all, his turned boxes and fluted carved bowls produced between about 1948 and the mid-1980s are lovely. Pye was ingenious. In 1950 he invented what he called a fluting engine to produce the subtle rhythms of shallow 'valleys' and ridges that animate the landscape of his bowls. In the 1970s he perfected a similar device for engraving the striations that are the hallmark of the lids he made for his turned boxes.

Yet, arguably, Pye's craft was repetitive and his designs took few intellectual risks. Pye's boxes and bowls are even limited as demonstrations of the role of workmanship since their very method of production avoids most if not all of the challenges met by designers for industry. This does not matter except that in each of his books he took the design world as a whole to task and since we cannot extensively judge Pye's arguments by what he himself designed we have to concentrate upon his writing.

This is no real hardship for, as a thinker about design, Pye was both adventurous and imaginative. His ideas tumble over one another in his

writing. His 1,200-word introduction to his *Nature and Art of Workmanship* is called 'Design proposes. Workmanship disposes'. This short introduction contains at least eight ideas:

1. The word 'design' is everywhere but there is no corresponding interest in workmanship.
2. Design can be conveyed in words and drawings; workmanship cannot.
3. The designer hopes the design will be good, the workman decides whether it shall be good.
4. Design can be nullified by workmen.
5. Our environment in its visible aspect owes more to workmanship than design.
6. The notion of good materials is misleading. Material in the raw is nothing. Only worked material has quality.
7. Good workmanship will make something better out of pinchbeck than bad will out of gold.
8. Our environment is not threatened by bad workmanship but by uniformity.[2]

Pye demonstrated his dismay about what was happening to the built environment in each of his books. Years before he had begun writing in the early 1960s, *Architectural Review* was criticising the aesthetics of the new Britain. Yet none of the *Architectural Review*'s perceptive authors, including Niklaus Pevsner and Ian Nairne, picked up on the issue of workmanship. The importance of workmanship and its contribution to appearance in design was David Pye's big idea, the one that makes Pye worth reading today. His books develop the theory that the appearance of the built environment is undermined by the workmanship of uniformity rather than bad workmanship. His argument is that we know of only four surfaces: matt, shiny, smooth and textured.

David Pye's concern with appearances was intellectually heretical. The intellectual debate that went with modernist design in the 1950s and 1960s was dominated by theory and by a conceptual, idealistic approach to design in which space and pure form were the attributes that engaged architects' minds. Materials and the way materials looked and were joined together were, apparently, secondary.

There arose, especially in architecture and in the fine arts, an assumption that the idea was more important than the appearance. This had some odd consequences. It was sometime in the early 1960s that the argument

was heard that if you did not like the look of something then it was because you did not understand it; if you understood a thing, then you would come to like it.

Such an argument is obviously fallacious. There is no necessary connection between understanding a thing and liking it. Yet it is the kind of thinking that characterises the defence that Sir Denys Lasdun, modernist architect of the Royal National Theatre, makes of his work. Lasdun, in many ways a great architect, does not appear to be concerned with the nuances of surface appearance. In 1994 he told the London *Evening Standard* that we are wrong to dislike concrete. He said, 'Concrete has become a cliché for attack. But we must learn to look with concrete-friendly eyes.'[3] The implication is that if we only understand why he uses concrete, then we will like it. Lasdun added that his favourite lines of poetry are from the Victorian poet, Arthur Clough: 'Pure form, nakedly displayed/ And all things absolutely made'.[4]

This is the kind of thinking David Pye opposed. He regarded such argument as hyperbole. Intellectually Pye pursued a two-fisted fight against what he saw as both the pseudo-scientific and the pseudo-poetic claims of modernism. On the one hand he attacked functionalism and on the other he argued for the importance of appearances and surfaces.

In order to clear the ground for the debate on appearance Pye knew he had to get rid of the doctrine of functionalism. Functionalism was an essentialist doctrine, it assumed that if only the essence of utility could be defined then the right form, and beauty, would follow. And as an essentialist doctrine, it was opposed to the idea that appearances could be the most important aspect of design.

Concerning David Pye's attack on functionalism, his most frequently quoted words on the subject are from *The Nature and Aesthetics of Design*:

> Everything we design and make is an improvisation, a lash-up, something inept and provisional. We live like castaways. But even at that, we can be debonair and make the best of it. If we cannot have our way in performance, we will have it in appearance.[5]

Romantic words. Pye had a way with words as a writer and here he sounds like an existentialist version of Noel Coward, but with these words he reaches out equally to the humanist, the religious idealist, the agnostic and the atheist.

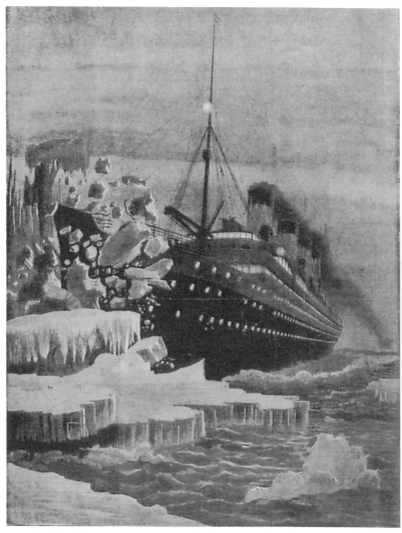

25 'We live like castaways. But even at that, we can be debonair and make the best of it.' The 'Titanic' colliding with an iceberg, 1912

Yet considering where we start from and bearing in mind the nature of nature itself, some of our lash-ups are impressive. Pye took a mordant glee in exaggerating the frailties of human accomplishment, conveniently ignoring that nothing in nature really works (it is all subject to the Second Law of Thermodynamics). Or rather it all depends what you mean by 'really works'. Even Pye made use of ambiguities when it suited him.

When ambiguities did not suit him he was a stickler for definitions. In *The Nature and Art of Workmanship* he wrote that definitions and terminology are crucially important and that scientific thought has been fruitful because scientific terms have precise definitions. (If Pye was sentimental in his writings at all then it was over the nature of science.) Pye said communication between scientists has, until recently, been almost entirely effective. On questions of art, communication has not been nearly so effective, there is so much noise. Yet he insisted that definitions are the only possible basis for communication. We must have definitions. If we cannot have final ones then we must have provisional ones.[6]

And so, in *The Nature and Aesthetics of Design*, David Pye began by demolishing the dictionary definition of function and replaced it with one of his own. He struck out the definition 'the activity proper to a thing, the mode of action by which it fulfils its purpose', and replaced it with 'Function: what someone has provisionally decided that a device may reasonably be expected to do at present.'[7]

He said whenever we design something in order to get an intended result we inevitably get other, unwanted results. We can never select the one result we want to the exclusion of all others: we cannot even select one source of energy to the exclusion of all others.[8] Pye remarked: 'The sun persists in heating things; the wind blows things over; moth and rust corrupt; and, above all, gravitation never lets up.'[9] Science, of course, provides the designer with principles with which to cope with the effects of wind, moth, rust and gravity. Design is, said Pye, the business of applying science in order to get as much of the result we want while not being troubled too much by the results we do not want.

One might think that because in any given design only one set of scientific principles would be appropriate, this fact alone would narrow down the choice of shape for the designer. Yet Pye argued perversely – but productively – that the designer has an infinity of choice.[10]

Pye took pleasure attempting to argue that even in straightforward

pieces of machinery shape is not necessarily critical. He considered wedges and hooks. He said that defining them by their form or their shape is not important, they need to be defined by their function – and when we do we will see, according to Pye, no necessary connection between their form and what they do. As he put it:

> The only way of closely defining the kind of arrangement of matter which we call a wedge or a hook would be by referring to the way it transmits forces. A hook will pull. A not-hook won't pull. Shape, individuality, doesn't come into it.

He said there is 'an infinite range of possible shapes for a hook'.[11]

His reasoning is exhilarating and exasperating. In general terms there may be no absolute or determining connection between function and appearance. But really Pye was leading us a bit of a dance, darting backwards and forwards between theory and practice.

For in principle there may be, as Pye asserted, an infinite range of possible shapes for a hook but in practice there are not. When we design and make a functional object we do not have complete freedom of choice. A designer is not free to choose any form, any more than the designer can be free of rust, moth and gravity. Designers are constrained by the materials and tools that are to hand, constrained by limitations of knowledge, constrained by tradition and affected, often unwittingly, by decisions made by other people, most of them anonymous. These constraints may be hazier than those of friction or gravity, and they may well be as unwelcome, but they are there. Complete freedom of choice over form is a myth.

The principle 'form follows function' is at least a helpful rule of thumb: it reminds designers of their responsibilities. We do expect a design – say a car – to be more than debonair. For example, the form of a car has a role in its function of cornering at speed. I have no desire to sail off into a ditch, however debonair I and the car may look as we do so.

'In practice', as opposed to 'in principle', the designer is not infinitely free in his or her choice of shape. However, the differences between the majority of shapes in this infinity will be so slight as to be below the threshold of our perception. No doubt every single thing we produce, even cola cans, is in some way different to every other because it has a slightly different arrangement of atoms. But if we cannot sense the difference then the difference is, in practical terms, meaningless to the designer unless it

has an effect upon the function.

More to the point – and this reflects on Pye's use of words such as 'provisional' to describe our efforts – we human beings, when engaged in practical pursuits, do not think in terms of infinite possibilities because we are finite beings. We are intensely aware of finiteness, we feel in our very being that our time is running on. Even megalomaniac dictators intent on building Third Reichs think in terms of empires lasting a mere thousand years. And in contradiction of Pye's general thesis that we live like castaways, it is astonishing how well and how permanently we can build – if, as is only reasonable, you judge permanence and durability by the life span of human beings rather than by notions of infinity.

I am also puzzled, in the context of Pye's debate about function, by the absence of any sustained reference or discussion to both craft terminology and craft tools because, bearing in mind the high value he placed on the clarity of scientific definition, it seems selective to ignore the evidence of both clear definitions and a practical, working relationship between form and function that exists in the human universe of tools and workshops. Consider the range of hammers: it includes mineralogists'

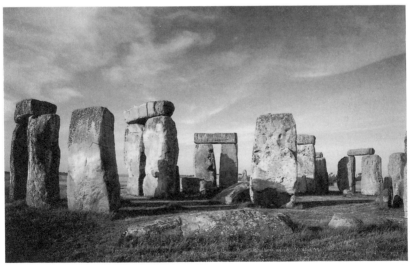

26 The sun persists in heating things; the wind blows things over; moth and rust corrupt; and, above all, gravitation never lets up'. Stonehenge, Wiltshire

hammers, slaters' picks, bricklayers' hammers, firemen's hammers, ship's carpenters' hammers, claw hammers and surgical hammers.

Of course, in another time, place and culture, the form of a tool for cracking rocks to find fossils or to help a person build a roof may be entirely different: rocks may be split open by laser beam or ultrasound and roofs may be grown biologically rather than constructed. But then function and the litany of hoped-for results is always specific to time, place and circumstance – provisional if you like, but no more provisional than anything else in nature. In our everyday lives function is a finite concept: the job needs doing now.

Indeed Pye retreated from his anti-functionalist design arguments in a discussion about standardisation in design. He said:

> Standardised pieces of material must essentially be versatile: a rolled steel angle bar may end up as a fence post, a frame of a boat, part of an agricultural machine, or a pylon, or a window. Thus standard pieces will, wherever possible, be squared or turned.[12]

So if you want versatility in mass-produced building components the components must be (a) standardised and (b) squared or turned. Out goes the great variety of shape or form argument. Function does narrow down the infinity of forms after all and may sometimes determine form. Despite all the noise and bluster, the conclusion that Pye arrived at is much weaker than the banging and clanging of his earlier pedantry led one to expect. He said: 'The designer always has more freedom of action than appears at first, and particularly in the matter of detail and finish.'[13]

Few designers would demur at this. Yet the argument leading to this muted conclusion is thought-provoking and even fun. Pye's ideas about function lead naturally to his concern, his big idea, about the importance of appearance. He argued that appearance owes more to workmanship than to design, that appearance has been subverted by uniformity. Yet the technology of uniformity in design is rooted in a desire that Pye himself had great sympathy with: a desire for clear definitions, for clear communication between human beings.

As we know, Pye insisted that precise definitions were the only things that made communication possible between people. Pye may have been mistaken about this but it is true that where you can fix a meaning in such a way that it does not change when it passes from person to person, and

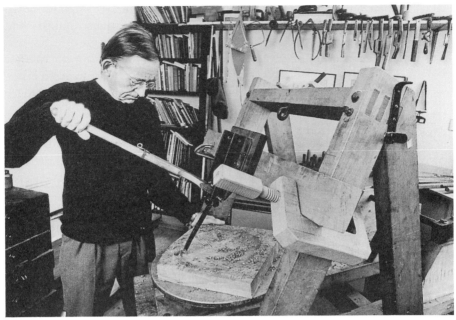

27 David Pye in his studio

language to language, then a powerful communication tool has been created.

Clear chains of communication are among the most desired features in any practical activity where more than one person is involved in making or doing something that is complicated. One difficult aspect of making complex objects – be they railway locomotives or office blocks – is communication between the many people involved in the process. Understanding what each means is absolutely critical.

And just as it helps to have an agreement about terminology, it also helps to have an agreement about objects. So that, for example, having a kit of standardised parts not only gives you versatility, it also gives you predictability. And this applies to surface components as much as it does to structural ones. For example, there is a standard, international chart of colours – the Pantone colours – which allows you to specify a particular blue in the expectation that a person 2,000 miles away knows exactly

which blue you want and, moreover, can supply it. Standardisation diminishes the chance of nasty surprises for designers, builders and clients.

The more uniformity, the less surprise, and the less surprise, the less chance there is for mis-communication. Yet, in our efforts to avoid disappointment we are laying the ground for disappointment. We pay for efficiency with dullness.

Dullness occurs wherever anything deemed 'useless' or a luxury is ruled out. In *The Nature and Aesthetics of Design* Pye provided a chapter on 'Useless

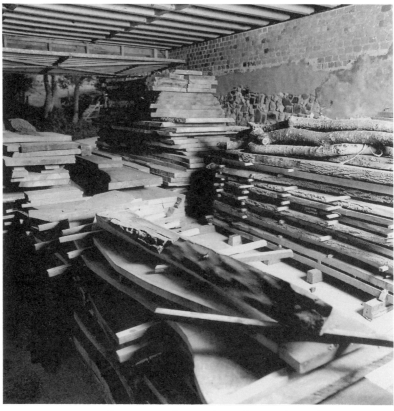

28 'We see one thing and one thing only: surface, the frontier
of something invisible.' Alan Peters's wood store, 1994

Work' which begins characteristically by challenging the dictionary. He stated, 'There is a difference between useless and ineffectual, no matter what the dictionary says.'[14]

Dictionaries have moved on since Pye looked up useless and ineffectual, since mine are clear on the difference between the two words. But Pye used the difference between 'useless' and 'ineffectual' strategically to highlight the fact that a lot of what we value in any design is not related to the function but to how it feels and looks. He talked about the extra work we put into the detailing and surface finishing of objects – none of it needed for function but all of it desired, none the less.

And, indeed, much useless workmanship is expended on surfaces. Pye insisted that it is difficult to over-emphasise the importance of surface quality. We see one thing and one thing only: surface, the frontier of something invisible. It is, undoubtedly, one of the losses of our culture that we are so bound up with utilitarian thinking that we forget the sensuous nature of seeing. The big loss in architecture is the surface. We are capable of generating interesting forms but the planes in between are a blank.

And Pye's argument was that appearance should be a goal in itself: it does not need to relate to a structure or to express the function. Appearance can relate to structure, it can 'express' function but if so then it is a choice of the designer, not a logical necessity.

All Pye's energy as a thinker and writer flows from his crusade against the dogma of modernism. The philosophy of modernism, its ability, like so many other nineteenth- and twentieth-century ideologies, to put an idea, an ideal, above the evidence of what we see, alarmed and appalled Pye. To some extent he was a lone voice and in truth his ideas have not been discussed as widely as they should have been. His approach was also too English, too prickly, not metaphysical enough for current tastes and, it must be said, the detail of his reasoning is often shaky. Why read him? Partly because his roistering approach to argument is fun, partly because he forces the reader to think about many aspects of the process of design, and partly, of course, because he speaks up for appearance. Putting a good face on things is a fine English tradition.

Notes

1 A. Frost, 'David Pye', obituary in the Independent (6 January 1993), p. 23.

2 D. Pye, *The Nature and Art of Workmanship* (Cambridge, Cambridge University Press, 1968; paperback edn, 1978), pp. 1–3.

3 D. Lasdun, 'How Dare They Mess With Magic?', *Evening Standard* (24 June 1994), p. 9.

4 *Ibid.*

5 D. Pye, *The Nature and Aesthetics of Design*, (London, The Herbert Press [1978] 1983), p. 14.

6 Pye, *The Nature and Art of Workmanship*, p. 20.

7 Pye, *The Nature and Aesthetics of Design*, p. 14.

8 *Ibid.*, p. 18.

9 *Ibid.*, p. 19.

10 *Ibid.*, p. 25.

11 *Ibid.*, p. 24–5.

12 *Ibid.*, p. 50.

13 *Ibid.*, p. 76.

14 *Ibid.*, p. 77.

MARIANNE STRAUB

MARY SCHOESER

ARIANNE STRAUB's ambition was to create well-designed, afford-
able cloth. She was well on her way to this conclusion – in part
through her experiments on a narrow strip loom given to her in
about 1921 – before she began studying handloom weaving in 1928, at
the age of nineteen. With her roots in the craft tradition well-nourished by
her course at the Kunstgerwebeshcule in Zurich, which was concluded in
1931, she knew that it would only be through an understanding of power-
loom weaving that she would be able to reach her goal. For six months she
then worked as a technician and helper in a mill in her home village of
Amriswil, learning to cope with temperamental and complex powered
dobby looms; during the same period, from July 1931 to March 1932, in
her studio at home, she set up a 16-shaft dobby handloom and wove
cotton and linen bedspreads, curtains and cushion-covers to commission.
The marriage of craft and industry represented by this brief period was to
be duplicated throughout her career; this essay explores those connections
and their contribution both to her own work and to broader develop-
ments in Britain in the years since 1933.

Marianne Straub came to study in Britain because neither of the two
Swiss technical colleges would accept women. Determined to gain a
thorough knowledge of the mechanical, theoretical and scientific aspects
of powerloom weaving, she entered Bradford Technical College in
September 1932, only the third woman to do so. During the following
nine months she studied textile maths, powered spinning, weaving
technology, cloth construction and raw materials. The college's location in
a wool town determined that woollen cloths were given greatest priority,

and she developed a keen interest in the endless variety of wool fibres. She also enjoyed a Saturday morning 'game' in which the teacher of weaving technology, and the technical staff, upset the mechanism of a loom and asked for it to be put right. It was at Bradford that she honed her skill in doublecloth construction and found a great interest in the ability of the powerloom – in its own right – to produce beautiful cloths.

She took these interests with her to Ethel Mairet's studio, Gospels, which she visited in the spring of 1933 and to which she soon afterwards returned for a nine-month stay. This was to be a period of exchange. The young Swiss weaver introduced a variety of doublecloth weaves to the studio and banished Mrs Mairet's scepticism about the benefits of technical training. In return, as well as her first experience of hand-spinning and -dyeing, she gained the vital support provided by the friendship that formed between the two weavers, which was sustained by three annual European trips taken between 1936 and 1938, and subsequent sojourns to Gospels during the 1940s. The wider impact of this friendship cannot be underestimated. The firsthand exposure to the English craft tradition and many of its leading practitioners (not just in weaving, but also in pottery and lettering) gave 'craft credibility' – if that is not too strong a term for it – to Marianne Straub as she pursued her career as an industrial designer from 1934 to 1970. It allowed her voice to be heard in the debates surrounding the future of craft. At the 1952 Dartington Craft Conference, for example, she argued for the preservation of those who 'know the whole thing from beginning to end. We craftsmen have that inheritance and we must keep it because that inheritance is of tremendous value.'[1] Ethel Mairet, on the other hand, gained a firmer conviction that standards in industry could be raised by the production of handwoven prototypes. She knew this concept had been introduced at the Bauhaus in 1927 and in 1933 she had witnessed Elsa Gullberg doing just this in Stockholm, but it was her knowledge of Marianne Straub's handwoven prototypes *and* their powerloom equivalents that lent authority to her espousal of this idea.

The influence of Marianne Straub's rare combination of craft and industrial skills can be seen in her work as a peripatetic designer for seventy-two Welsh mills (1934–37), as head designer of the Barlow & Jones subsidiary Helios (1937–50, from 1947 also managing director), and as a designer for Warner & Sons Ltd (1950–70). She believed it was essential to:

know our raw materials. It is a world in itself. You can spend a year getting to know all the fleeces and another fascinating year spinning yarns from all the wools you can get. You can weave a plain weave, and there is nothing in the world better ... a plain weave fabric woven from a yarn which has the right quality and which represents the full liveliness of the fibre can be as beautiful as the finest brocade, damask or velvet.[2]

This is borne out in her Welsh upholstery cloths, with weave structures that enhanced the natural elasticity of wool and provided the 'give' required for the controlled curves of furniture by Gordon Russell and Ernest Race, who went on using these fabrics into the 1950s. It can be seen in her ability to meet stringent flammability and 'rub-test' standards with cloths designed at Warner's for the Ministry of Works. And it can be seen in her choice of colours for the Helios range, which were chemically dyed and for which she had to estimate the different way in which different fibres absorbed and reflected colour and light respectively, so that they would work together as one colour.

Her understanding of the natural dye palette was apparent in cloths produced throughout her career. The Helios range had, typically, five or six standard yarns each dyed in up to ten or twelve colours; these not only duplicated the warmth of madder reds, indigo blues, weld yellows and fleece browns, but also created natural harmonies when used together. During the Second World War new colour ranges were evolved by using the existing stock combined with one yarn dyed in several colours; she also exploited the wide range of 'whites' available from undyed yarns. Helios also had a range of hand-screenprinted textiles which showed an equal sensitivity in their colouring; although purchased from freelance designers and artists, including Noldi Soland, John Farleigh, Graham Sutherland and Jane Edgar, the colourways were created by Marianne Straub. (Some designs for Jacquard weaves were also purchased and, for a short period, Otti Berger was retained to design dobby-woven cloths.) Many of the designs were never produced, but their purchase provided support in a number of key areas to the Cotton Board's Colour, Design and Style Centre, which held its first exhibition in the winter of 1940–41 and from which came designs by Hans Tisdell, Vanessa Bell and John Aldridge; to recently arrived *émigré* designers such as Marianne Mahler and Jacqueline Groag; and to the teachers (Margaret Simeon and Dora Batty) and students of the London art schools, St Martin's and Central.

Marianne Straub's knowledge of both hand- and machine-spinning meant she was able to create prototype yarns for the Welsh mills, which in the 1930s still retained their traditional practices, using local fleece chemically dyed – if at all – prior to carding. By mixing the colours during carding she was able to produce subtle shadings, and this practice contributed to the success of her suggestion that they spin knitting yarns and weave tweeds and flannels to match. By combining 'S' and 'Z' spun yarns she created cloths with muted stripes, and this technique was also introduced to Gospels during one of her visits. Her training allowed her to exploit combinations of fine and coarse yarns; by using Welsh wool with a spiral knitting yarn in one of several cloths selected by Hardy Amies, at Lachasse in 1935, she introduced the high texture that was more naturally associated with handwoven cloths. These were among the few fabrics designed for clothing, a feature of her work that she did not regret, having always been much more interested in cloths for the interiors of buildings and ships.

Because Barlow & Jones were fine-cotton spinners and weavers, her move to Helios also meant a change in yarns. No longer restricted to wools, she used cotton, linen, rayon, fibro and worsted. Felix Lowenstein created Nuralyn, a cotton and ramie yarn spun by Barlow & Jones and confined to Helios except for use in knitting.[3] Despite war restrictions, in place for most of her years with the firm, Helios gained a reputation for its innovative use of yarns. Mohair, cellophane, gold metal thread and glass fibre and filament yarns – all unrationed – supplemented dwindling supplies. Marianne Straub's insistence on yarns that were both practical and visually interesting gained the respect of Stopford Jacks, the sales director of R. Greg & Co. Ltd, cotton spinners, whose fancy yarns were often used at Helios, and another remark made at the Dartington Conference contains a sense both of their working relationship and the importance she placed on being able to spin, for 'if we have the knowledge of spinning and we have the feel of it we at least know what yarns to look for and we can ask for them and push people to make them. We can spin them a yarn.'[4]

Despite the change of fibres, her use of yarns at Helios showed a continued exploration of juxtaposed fine and thick yarns, or fancy and plain. She developed weave structures that pushed the fancy yarn to the face of the cloth so that they appeared to float across the surface, and

29 Mock leno cloth, linen with gold metallic thread. Developed as tablecloth for Helios *c.* 1941 and included in a selection of the work of members of the Society of Industrial Artists and Designers, *Designers in Britain,* 1947

30 'Goathland', semi-transparent curtain material with spaced Nuralyn warp
and fancy cotton weft. Designed and first produced for Helios in 1938.
Warner & Sons Ltd continued the supply of this cloth until the late 1950s

created other textural effects by burying fancy yarns in both warp and weft. She also exploited the ability of a knarled or gimp yarn to 'hold' spaces in the cloth. 'Goathland', one such fabric of Nuralyn and cotton, was developed in 1938 and continued to be woven at Warner's well into the 1950s. During that time the availability of yarns changed (something that was to happen over the lifespan of a number of cloths she designed) and the resulting request to alter the yarns but not the essential nature of the fabric was welcomed as a challenge rather than an insult to creative integrity.

The spaced reeding (which places the warps at varying intervals) on which the structure of 'Goathland' depends can also be seen in an Eri silk blouse fabric woven at Gospels, in a fine wool plain weave dress fabric woven by Holywell Mills, and in a number of cloths woven at Warner's, in particular a group of related cotton and viscose curtain fabrics designed for Tamesa between 1964 and 1969. All these, each subtly different and enhancing the natural character of the fibres, reflect Marianne Straub's ability to make her own warp. This may sound self-evident, but there were many industrial designers at the time who knew the principle but lacked the practice. Since all her cloths – with the exception of the Jacquard weaves designed mainly for Helios – were sampled on her handloom, there was scarcely a week that passed between 1933 and 1970 when she was not making a warp. And some of the powerwoven cloths for Warner's were designed in the knowledge that even for bulk production, hand-warping, still done at the mill, would prove less time-consuming.[5]

The practice of handweaving prototypes was to become particularly significant during her years at Warner's, when the economies of production placed great emphasis on cloths that could be woven without shuttle changes. Horizontal stripes, which were often incorporated into her curtain fabrics because they enhanced the cloth-draping qualities, required multiple shuttles, but inevitably meant that the cloth was slower to weave. Vertical stripes, on the other hand, were created by the warp; once on the loom the weaving progressed uninterrupted. This aspect of cloth construction was exploited to the full; some cloths, such as 'Broadfield' (for the Design Research Unit, 1952), deployed broad and narrow warp-faced stripes across the width of the cloth without repeating. Others, such as 'Chandos' (for Heal Fabrics Ltd and Ercol Furniture from 1960), used close tonal ranges arranged in a random fashion to create a seemingly solid-coloured fabric that flickered with life. By incorporating

areas of spaced reeding, stripes composed solely of weft were exposed, and by using a balanced weave (in which warp and weft were more or less equally visible), the variety of 'randomly' placed warp colours would become more muted. The latter effect was used in 'Munster', a fibro, wool and cotton upholstery cloth created in 1957 for Heal Fabrics Ltd. Three versions were designed as the availability of yarns fluctuated, and about 500,000 metres had been produced by 1970, most for the Ministry of Works, which used it in military installations and hospitals, where some still survives today.

As is apparent, there were distinctly different challenges offered by the Welsh mills, Helios and Warner's. In Wales Straub's role, above and beyond that of designer, was to convince the mills that they needed to change in order to survive; Holywell Mill made best use of her skills and it may not be coincidence that it still operates today. At Helios, created especially to provide well-designed cloths for the retail trade, she often acted as saleswoman, contributing directly to the growing surge of interest in modern design; this, in fact, was the experience that came closest to her original ambition. At Warner's she worked mainly for the contract trade; as a designer, she was one step removed from the customer. Despite these differences, throughout these years she worked closely with architects and furniture designers and, from 1956 until she moved back to Switzerland in 1992, she shared her wide-ranging experience with students. She taught one day a week at the Central School of Arts and Crafts (1956–63), Hornsey (1963–68) and the Royal College of Art (1968–74), subsequently gave advice and workshops at numerous colleges, and was closely involved in Professor Malcolm Burnip's development of a combined textile design and technology BSc course at Huddersfield University, introduced in 1977. In both teaching and industry she gave everything for the right results and nothing for fame; she was not acknowledged by her own peers until 1972, when she received the first Textile Institute design medal and was elected a Royal Designer for Industry. Her most visible work is in the London Underground's Piccadilly Line, which still has carriages upholstered with a cloth designed in 1964 and first used in 1976; few know who designed it.

Throughout her years as an industrial designer and teacher, the essence of Marianne Straub's application of craftsmanship was flexibility. She used her skills to negotiate with spinners, dyers, mills, clients, colleges

31 'Pony', warp of cotton fancy yarn with fibro slub and weft of two-ply worsted, Helios, 1940. Used for curtains in the first Council room of the Council of Industrial Design

and students, and did so over a time-frame that witnessed the effects of the Depression, war-time restrictions, rapidly increasing yarn prices, the introduction of stringent wear tests and finally – and as a result of the last two factors – the decline in the use of woven fabrics as the major furnishing cloth. Throughout, she was sustained by her respect both for the essence of cloth and for workmanship; as the horizons for industrial-weave designers narrowed in the 1960s, she could still prize the dyeing, warping and weaving by hand that went side-by-side with powerweaving at Warner's. Thoroughly modern in approach, she nevertheless also prized ancient and ethnic weaves, gleaning from them their lessons in technique, approach and sensibilities. This she did throughout her life, from the creation at Gospels of a doublecloth for a jacket, the combination of hand-spun blue cotton and machine spun thick, soft woollen yarns,

32 'Silverton', dobby-woven upholstery cloth with a subtle variation of colours in the mixed-fibre warp and incorporating lurex yarn in the weft, 1952-53. One of a handful of Straub's fabrics sold directly from Warners, it was produced in bulk until the mid-1960s

inspired by the 'warmth-inside' principle of a Mongolian padded jacket, to the development in 1981 of a link-warp technique that flows naturally from an understanding of Peruvian textiles.

Although by looking at raw material behaviour, dyeing, spinning and warping one can study the separate elements of craftsmanship that are evident in Marianne Straub's work, this was never the way in which they were actually created. Outlined in correspondence in August 1994, her design process is summarised as follows:

> Designing woven cloths is really involved in the construction of a cloth. For this reason I never did much design work on paper. Most of my designs are evolved at night in bed. The first thing is to deal with the actual problem in hand. Is it to be a cloth for a specific place; a chair, a curtain, a bedspread, etc? Is the size known? Are there specific colour requirements? It is essential that I know the yarn range that is available to me, but I can also dream up a yarn which I will ask a spinner to spin for the purpose. Whilst thinking of the new cloth, I think of its weight, its draping qualities, the handle; I see it in colours. And of course the cost of it at this stage may already be a deciding factor … The essence of the whole exercise is to place the cloth, in my imagination, into the situation in which it will be used. I can feel it in my fingers.[6]

In the same letter she described a recent visit to 'an Ikle once removed' (a descendant of an admired acquaintance) who had been given some dyed worsted yarn with which to weave; 'Working with enthusiasm for three days produced, I think and hope, a nice fabric for which the warp was ready when I left'.

This was written six weeks prior to her eighty-fifth birthday and twelve weeks before she died on 8 November 1994. It is interesting for three reasons. The first is that it takes us back full circle to her friendship with Ethel Mairet, and a trip they made together in 1938, when Mrs Mairet was in the process of writing *Hand-Weaving Today*, in which she discussed the lack of proper training schools to advance a modern concept of crafts in relation to machinery; in Switzerland they met Herr Fritz Ikle, whose family is referred to above, and with whom they discussed ikats and Peruvian textiles. The second is that it demonstrates how integral handweaving was to Marianne Straub's existence. Her age, too, is significant; that she long outlived Ethel Mairet, as well as Alec Hunter and

Alistair Morton – the only others who could lay equal claim to both the pre- and post-war English craft and industrial traditions and whom she knew well – made her, from the late 1960s onwards, the last to hold intimate knowledge of a dream they all shared. She can be likened to a vessel, into which was poured a rich mixture of craft and technical training and from which she believed 'We all have to give, and we must give, and we must help each other, and we must keep that tradition alive because it is a most valuable one'.[7] In the tremendous increase in innovative weaves being produced today, that tradition is more alive than it has been for thirty years. Influence is difficult to assess and too easy to overestimate, but at the very least Marianne Straub deserves credit for over fifty years of nourishing, even battling for, the integrity of cloth and the creativity of those who wish to make it well.

Notes

1 'Beginning at the beginning', paper given by Marianne Straub at the Dartington Hall Conference, 1952 (pp. 32–9 of transcript).

2 *Ibid.*

3 Former owner of Pausa, the German mill that wove many Bauhaus cloths, and managing director of Helios from its foundation in 1936 until his death in 1947.

4 Straub, 'Beginning at the beginning'.

5 The written details and samples of every 1950–70 warp, and the various designs and colourways worked on them, are preserved in the Warner Archive; the average number produced by Straub is 100 warps per year.

6 Correspondence from Marianne Straub 12–17 August 1994. M. Schoeser, *Marianne Straub* (Design Council, London, 1984).

7 Straub, 'Beginning at the beginning'. See also M. Schoeser, *Marianne Straub.*

<div style="text-align: center">

LUCIE RIE and her work with HANS COPER

TONY BIRKS

</div>

WITH THE DEATH of Lucie Rie, aged ninety-three, on 1 April 1995 a ceramic legend was finally laid to rest. Although ill and incapable of communicating with the outside world for the last two years of her life, this laconic artist maintained an aura of uncompromising 'correctness' which encompassed high standards in her work, her professional and private life, and a single-mindedness that only those without families, or oblivious of families, can pursue. She outlived her friend and mentor Hans Coper by nearly fourteen years and, sustained and encouraged by her advisors, produced in those years some unique, outstanding and personal work. But the clockspring that had made the pair of Coper and Rie the most innovative partnership in British ceramics this century slowly ran down when the latent energy of Hans Coper was removed.

Lucie Rie was a complex character, often at odds with the vagaries of an absurd and sometimes hostile world. Single-minded and saintly, she was also short of self-confidence, absurdly loyal, waspish about and disdainful of the insincere and pompous, independent of spirit yet emotionally dependent, and always needing and seeking the support of a close circle of friends, mainly men. She never recovered from the trauma of the 1930s but her strength of character kept this well concealed, and she could never have been construed as weak or vulnerable. Hans Coper described her as a steel fist inside a velvet glove, and to many only the velvet was evident, a genuine shyness combining with old-fashioned courtesy. In Hans Coper she found the perfect man. She was able to relate to this intelligent artist in every way, to recognise and understand his

experiences as a fellow Jew and to form with him a working partnership
(not a sexual one) in which he was the innovator and she the enabler. Her
admiration for Coper was total, and she said of herself in the context of
their partnership, 'I am just a potter'. This was not false modesty, nor was
it a devaluation of the status of the potter; she was simply contrasting her
position as a creative craftsperson in pursuit of excellence with Coper, the
major artist. Between them they changed the face of ceramics forever.

If one were to ask, 'Who are the most influential potters in Britain in
the last quarter of the twentieth century?', it is most likely that the
consensus view would be Hans Coper and Lucie Rie. Yet if the question
were to be rephrased, 'What kind of pottery has been the most influential
in this period?', then the answer would have to be handmade pottery and
special firing techniques such as raku, salt and smoking. There is
absolutely no trace of these techniques in the work of Coper and Rie. They

33 Lucie Rie and Hans
Coper working side by side
in Albion Mews, 1950s

were wheel-based container-makers, who never strayed beyond the oxidising atmosphere of an electric kiln.

With the 1990s fashion for 'working with the fire', it would seem likely that wheel-based throwers like Rie and Coper, making their most innovative work in the 1960s and 1970s, would by now have been sidelined, but this is not the case. The current generation of potters for whom ceramics is an expressive and non-functional art form have an intense respect for Rie and Coper, but without copying either their techniques or their forms.

Hans Coper and Lucie Rie, unlike Bernard Leach, did not set out to influence other potters, and never propounded theories or wrote about their work. There is no doctrine or philosophy of design attributable to them, and indeed each was extremely reluctant to put their name to written work. They would not speak in public – such a prospect would have been anathema. When in the late 1980s Lucie Rie was persuaded to open the Chelsea Crafts Fair in London, it was on condition that she did not have to say anything, and when others spoke about her, for example at openings of her exhibitions, the longest response she ever made was two words: 'Thank you'. With her sharp intelligence she would deflect questions about her attitude to the craft of pottery, and avoid intellectual discussions: 'I close my eyes and make pots.'

Hans Coper, whose intellectual stature in spite of his modesty was obvious to all who met him, carefully avoided making statements about ceramics, and the single paragraph that he wrote for the catalogue of the Victoria and Albert Museum exhibition in 1969 was the extent of his published writing. It is a very moving piece which somehow shows the density or *gravitas* of whatever he did. Hans was not a solemn man – he had a marvellous sense of humour – but when it came to writing I feel he would have avoided the trivial, and would have written interestingly and probably passionately about anything. We know that in the last two years of his life when he was no longer potting he wrote a great deal, but unfortunately for posterity burnt all these writings before he died, almost certainly because he did not want to leave anything behind him that did not match the standards he set for himself.

So from neither artist do we have a written philosophy, and even in their teaching there was no theory expounded. Lucie Rie disliked teaching and was not very good at it. She did it out of a sense of duty, but had no

teaching skills. Ian Godfrey said, 'She always claimed that she never taught me anything, but she did, by her mere presence.' As a teacher she preferred to be a demonstrator. When she gave up, it was with relief; she felt there was no place for her when the techniques she had to impart appeared to have nothing to do with the work of her current pupils, and privately she deplored the work of most of them.

Hans Coper was a marvellous teacher. His pupils found him an inspiration, and waited for his day at college as if Jesus or John Lennon were coming. Some felt that their work at college was done primarily to please him, yet Hans himself regarded his teaching as 'humbug', and rather despised himself for taking on the job because he needed the financial security that it brought. He was totally uninterested in the status that his lectureship conveyed. He enjoyed the meeting of minds with college staff in other disciplines, and he much enjoyed the company of aspiring, dedicated and talented young people. He tired himself out by talking to students and, with the concern of a man whose youth had been tormented with doubts and difficulties, he tried sincerely to understand the motivations and problems of these individuals. But he felt that as a teacher he was a fraud: he had no teaching philosophy as opposed to personal philosophy, and believed that to impose on others a view of ceramics was an intolerable impertinence. The closest he might have got to a teaching structure or plan was to keep in focus his simple touchstone 'why before how', which reflects an intellectual questioning of decoration for its own sake and his awareness of Bauhaus theories and functionalism.

So, with no writings, and teaching influence only brought to bear on the few who were their pupils, and with limited activities on selection committees, one has to look for the influence of Hans Coper and Lucie Rie in the effects of their work. Many times I have heard people say that seeing pots by Hans Coper and Lucie Rie in an exhibition has changed their lives. Their impact is very strong, as a new generation of Americans discovered when their joint show opened at the Metropolitan Museum of Art in New York in 1994. And in mixed exhibitions their work stands out by its excellence. What the observer sees in one of their pots (or discovers by handling it) is a striving for excellence that was at the centre of the life of each artist. Hans had said that his teaching was humbug and Lucie that she was 'just a potter'. Each meant that their pottery mattered more than anything else to them, and their motivating force was to make better pots.

To come to an understanding of this work, it may be helpful to give a brief *resumé* of the background of each artist. Lucie Rie was born in 1902 in Vienna, Hans Coper in Chemnitz in south-eastern Germany in 1920. They both came to England to escape from the persecution of the Jews in the 1930s, just before the outbreak of war. Their experiences before and during the war were pretty terrible, and in Hans' case quite terrifying and pathetic, but the two did not meet until 1946. Lucie Rie had been born in a very exciting age, for Vienna in the first decade of this century was the world's melting pot for design theory. The Wiener Werkstatte was flowering and then fading as she grew up; the rumblings of expressionism were echoing around the city with Kokoschka and others, and of course there were Mahler, Freud and Hoffman. However, Lucie's arrival on the art scene was a fairly serene affair. She was not stirred by the artistic upheavals around her, and one can imagine her rather like a well-connected upper-class young English girl arriving at the Slade School of Art, whose only brush with the creative arts up to that time might have been the occasional artistic weekend visitor at the family's country house. She remembered the Wiener Werkstatte as the place she went to with her parents for Christmas presents, and her circle of friends throughout her art school years kept her clear of the scruffier and more unruly elements of Viennese coffee-house society. But there was the pottery wheel which was for her a magical attraction from her first day, and she was under the eye of the great Josef Hoffman who saw in her a promising and inventive pupil. She was soon making pots which related to the stark lines of post-Secessionist architecture, and with their simple pure forms heavily encrusted with painted glazes she was doing something original. Chance had brought her to pottery. It was a toss-up between art school and medical school. If things had been different, she would have been a doctor like her father.

Walter Gropius has said, 'All art ... serves building', and although it is unlikely that Rie came across the view at first hand, she was making pots 'for the house', and some of the most advanced architecture in the world was in Vienna. It was the young architect Ernst Plischke who encouraged her, and Josef Hoffman who saw that her work was exhibited. By the time she reached England in 1938 she had gathered gold and silver medals at international exhibitions in Brussels, Milan and Paris, and had exhibited in Italy and in England too. But it is well known that her reputation did not extend to England, and her work was not actually liked by the English

luminaries such as W. B. Honey, William Staite Murray and Bernard Leach, when she showed it to them.

Leach certainly was an exponent of fluency in the handling of clay. Lucie Rie watched in awe as he worked on the wheel and she said she knew she was in the presence of 'the Master'. This must have gratified Leach, but it did nothing for Rie, who was knocked off balance as she tried to adapt her modernist and essentially taut forms to accommodate the generous round lips and substantial handles of the English ware, the virtues of which Leach extolled. Rie's capacity for work and her determination caused her to experiment with forms and to modify Leach glazes downward in temperature to suit her earthenware kiln during the grim days of the war, when her main work was in the war effort or in button-making in her newly acquired studio north of Hyde Park. It was in 1946 that the catalyst came, with the arrival of Hans Coper on her doorstep, looking for a job.

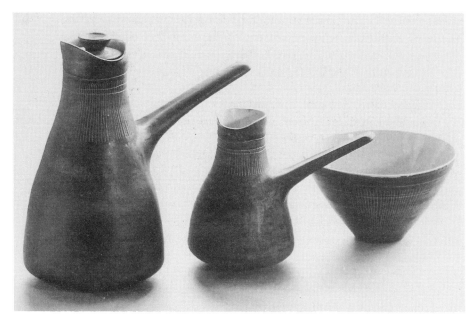

34 Straight-handled tableware by Lucie Rie with sgraffito decoration. Countless vinegar jars and cream jugs with straight handles from the Rie workshop were sold at Heals in the 1950s. Hans Coper shared in their making

He was twenty-six, an able draughtsman much under the influence of a creative architect friend, Fritz Wolff. He wanted to be a sculptor but was without training and desperately poor. Coper had been keeping body and three other souls together by doing various repetitive jobs, and the prospect of making buttons must have seemed just another opportunity of earning a meagre living. He found in the workshop of Lucie Rie not only a welcome and employment with congenial company but also an opportunity to set out on a career as a three-dimensional artist. The fact that Rie took him on when orders were apparently low must have had something to do with his personal charm and his plight, but there is no doubt that this serendipitous event has as much significance as any other

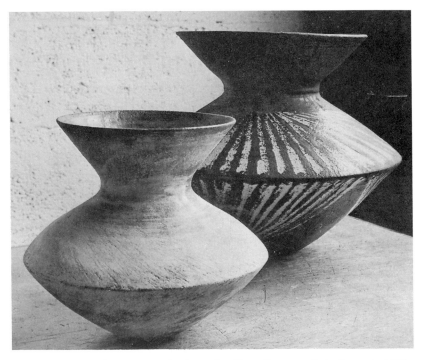

35 Two large composite forms by Hans Coper made in the early 1950s at Albion Mews. Hans made three bowls for each form and joined them when leather hard

in the history of British twentieth-century ceramics.

Lucie did not teach him to use clay on the wheel. Instead she sent him south of the Thames to learn the techniques from Heber Matthews, a distinguished potter from Staite Murray's Royal College of Art stable, and she was amazed by Hans' application. She had been stunned first by Leach's fluency and masterly craftsmanship, and now, six years and a World War later, by this young man's magical skills in working on the wheel. Although he was only twenty-six when she was forty-four, he already, through Fritz Wolff, had a wider background knowledge of the arts and architecture than she, and knew about the Bauhaus, sculptors Brancusi and Marino Marini, and had the maturity to be able to appreciate the early Viennese Rie pots, which had puzzled Leach, in their modernist context.

It was an exciting time. Britain was rebuilding after the war, and the war itself had created a clean slate in many areas of design. Coper and Rie were not the only refugees from Europe to make their mark upon it. In 1948 a new and massive kiln was bought, and came to occupy about a quarter of Rie's Albion Mews workshop: it could be fired to stoneware temperatures. The button business was allowed to decline, and Rie and Coper set about producing domestic ware in the now-famous chocolate and white stoneware glazes based on manganese and tin. It was not a question of two designers sitting down at the drawing board to produce a blueprint for new tableware. Neither potter thought in this way; they worked at the wheel. The relationship between the pottery industry and artists was extremely shaky during this period, and although these two artists could and should have had an impact on the ceramic factories, it was in other areas that their innovation was noticed.

A series of successful exhibitions at the Berkeley Galleries, Primavera and the Festival of Britain led to a regular marketplace for their work in the pottery department of the influential furniture store Heal's. The importance of the regular orders from Heal's in assisting the path of Rie and Coper as innovators is often overlooked. It was here that the crisp, upward-thrusting cups and smooth-profile saucers were first offered to the public at large. It was here, too, that the straight-handled jugs and ladles came into public view. (It is impossible now to know which of the two potters was the initiator of this revolutionary idea, so characteristic of the optimism of Festival of Britain 'contemporary' design.) And it was to

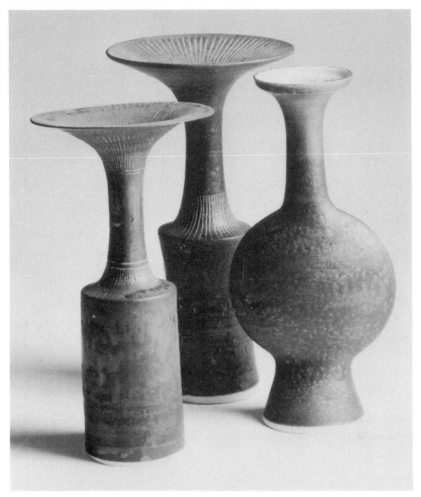

36 Composite forms by Lucie Rie. For several decades Lucie used a combination of a cylindrical body with a separately thrown attenuated neck to make a well-liked design, usually decorated with sgraffito. The pot on the right has its body made from two thrown discs set on edge, a practice she followed in the 1950s when she shared her workshop with Hans Coper. It is not known who used this technique first

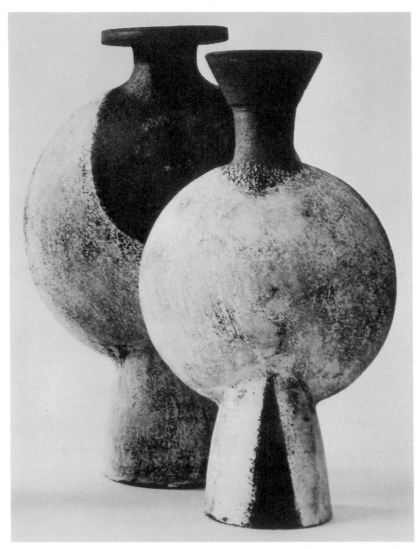

37 Composite forms by Hans Coper, early 1950s. Two thrown discs, set edge on, with an added stem and neck, were the basis of one of the revolutionary designs from the Albion Mews period. Both potters used this system in their distinctively different ways

tableware for Heal's that Rie first applied the sgraffito technique of fine parallel or radiating lines which allowed her to avoid experimenting with other forms of surface decoration. Lucky were those who bought pots from Heal's in the early 1950s, for they participated in a quiet design revolution which led away from bulbous English 'medieval ware' and imitation orientalism.

At the same time each artist was developing individual work for exhibition purposes, and as we now know providing the material for a new generation of collectors. This was composite stoneware: thrown units, combined when the clay is leather hard to make forms that showed counterpoint between the constituent parts, and was nearer to sculpture than to functional ware. Here was true innovation. Bowls placed rim to rim to make discus shapes would be set vertically on edge, with thrown necks and bases above and below, forms squeezed and slotted into each other to create shapes that the wheel alone could not possibly provide. For Coper, the development of this technique was an opportunity to exercise his sculptural skills to create harmony from wheel-based units in unnatural relationships. To this he devoted the rest of his life. There are Hellenic examples of combined forms, both decorative and useful, which form a precedent and one can see the influence of African and primitive art, but Coper was doing something original in his century, and as close to modern sculpture as his bold abstract black and white designs on dishes were to the painting of Picasso and Braque.

Rie used the same technique to make attenuated ceramic shapes which include some of her finest work, but they remained pots, not sculpture. The essential relationship between the artists is now becoming clear. Coper was the innovator, Rie the refiner. She was not particularly imaginative, as she herself said, but when given an idea she would adapt it to perfection. Her time-consuming sgraffito and fluting techniques, her wide range of textured glazes and her instinct to experiment ensured that she never resorted to a short cut and never made the same pot twice. It was not in her character to compromise, or to take an easy option.

When Hans Coper left the Albion Mews workshop in 1958 he continued on his own to build ever bigger combined forms through the 1960s and smaller dense ceramic sculpture up to the end of his life. As far as Lucie Rie was concerned, even after the working partnership ended, the new forms and glazes she made had to pass the 'Hans test' of approval

before she was satisfied with them. It could be said that Coper suppressed her work in terms of colour and richness, preferring to keep her on strict modernist lines with subdued colour schemes and clean, uncluttered profiles. The more florid, colourful Viennese side to her work only re-emerged after his death.

Hans' ceramic career spanned about thirty years – half of his lifetime. Rie's pot-making continued (with only the wartime wobble) for nearly sixty years, and both artists were abundantly productive as well as innovative; thus many examples exist in public and private collections worldwide. As people, their retiring natures meant that they were known only to a few, though to these few their personalities were unforgettable. It was through their work that they became legends in their lifetimes, relating twentieth-century ceramics to modern living, and breaking with an ingrained tradition. For potters working today it is hard to imagine how difficult it was in the 1950s to break free. It is no real criticism of Bernard Leach that his work, for all its lusciousness, appealed mainly to an intellectual coterie, familiar with the ceramics of the past. Equally it would be an exaggeration to imply that Lucie and Hans brought modern ceramics to the masses. But their innovatory and original work had an appeal and an effect stretching far beyond the aforementioned limited audience. Above all, it encouraged in the young both the challenge of excellence and the freedom to be different.

GERALD BENNEY

ERIC TURNER

GERALD BENNEY's career extends over forty years. During that time, he has established himself as one of the major British silversmiths of the second half of the twentieth century. He is the only silversmith holding four Royal Warrants, granted by the Queen, the Duke of Edinburgh, the Queen Mother and Prince Charles. Over the years, he has held various official appointments which have included a visiting Professorship of the Royal College of Art (1974–83), membership of the British Hallmarking Council (1979–83), Chairman of the Government of India Hallmarking Survey (1981), and Advisor to the UK Atomic Energy Ceramics Centre (1979–83). He is a Liveryman of the Worshipful Company of Goldsmiths and in 1971 was made a Royal Designer of Industry. In recognition of a long and distinguished career, he was awarded the CBE in the New Years Honours list of 1995.

As with most successful careers, the foundations were laid at an early age. Gerald Benney was born in Hull in 1930, the son of an art-school teacher. During his childhood, the family moved to Brighton when his father was made Principal of the Brighton School of Art and Design. His father's influence on his artistic talents has never been openly acknowledged, although it is clear that he was responsible for nurturing them to some degree, since his son became a student at Brighton in 1948. It was there that Benney first became interested in silversmithing when he met and studied under Dunstan Pruden (1907–74), the first of the two most influential teachers during his student career. (The other was Professor Robert Gooden at the Royal College of Art.) Pruden has always remained an underrated talent. He was a gifted teacher and his textbook,

Silversmithing, Its Principles and Practice in Small Workshops, published by
the St Dominic's Press in 1933 and illustrated with a series of beautifully
executed wood engravings, demonstrates the simplicity and clarity of his
approach. Benney has always been the first to acknowledge the debt he
owes him.

Pruden learnt his craft at the Central School of Arts and Crafts in the
mid-1920s under Onslow Whiting, and then worked as an assistant to the
London goldsmith, F. Morton Crookes. A deeply religious man, he was
brought up a High Church Anglican and, in early adulthood, converted to
Catholicism. An equally profound influence in his youth was Eric Gill
(1882–1940). Shortly after leaving the Central School, Pruden gave a
lecture on Gill which brought him to Gill's attention. A meeting was
subsequently arranged from which both discovered that they shared a
common outlook when it came to questions of art and craftsmanship and
their inter-relationship. Their bond was further cemented by their intense
religious convictions and it was therefore inevitable that Pruden was
drawn to the Guild of St Joseph and St Dominic, a religious fraternity
established by Gill in the Sussex village of Ditchling.

Gill's own conversion to Catholicism had come about through his
desire to find an all-embracing philosophy that would introduce system-
atic order to both his artistic and personal development. The Guild,
formed in 1920, drew together a small group of Catholic craftsmen who
shared similar beliefs. In many respects its core values were a reflection of
the Arts and Crafts movement founded forty years earlier, with the excep-
tion of its religious basis which is what gave it its unique quality. It
remained remarkably true to its founding principles until its eventual
demise in 1988. If there is any one characteristic that summarised the
Guild's philosophy and permeated all its members, it was the belief in the
ultimate integrity of the work of art and, concomitantly, that it was the
responsibility of the artist to achieve it. This attitude underpinned
Pruden's work and teaching and impressed itself upon the young Benney
when a student. One can therefore trace an important element in Benney's
work – the quality of individual craftsmanship – back through Pruden to
Eric Gill, and ultimately to the values of John Ruskin and William Morris
which led to the foundation of the Arts and Crafts movement.

Gill's early departure from the Guild in 1924 and the consequent loss
of his charismatic leadership gave it a seismic shock from which it was able

to recover but which left lasting scars on some of Gill's closest friends and associates. Pruden's relationship with him survived. He was younger and, since his membership of the Guild did not overlap with Gill, he did not experience the same feelings of betrayal. Gill was instrumental in obtaining Pruden's first important commission in 1932: a silver altar cross for the chapel of Exeter College, Oxford, which effectively established his public reputation as an ecclesiastical silversmith. Given his religious background, Pruden showed equal facility in providing church plate for both the Anglican and Catholic churches. It is no coincidence that Benney has inherited Pruden's mantle as a great ecclesiastical silversmith and he openly acknowledges that the influence of Ditchling gave him a fluent understanding of church liturgy and a practical grounding in expressing its requirements through silver in a contemporary idiom. His important church commissions have included, for example, a travelling cross for the Archbishop of Canterbury, the St Dunstan's Cross for St Paul's Cathedral, commissioned by the Goldsmiths' Company, the altar cross for Mary Queen of Scots Chapel at Westminster Abbey and the altar cross for Dublin Cathedral. Benney has shown that he can bridge the ecumenical divide, which is further reinforced by the numerous commissions he has successfully carried out for Jewish ritual plate.

If the foundations of Benney's career were laid in Brighton, its edifice was built at the Royal College of Art (RCA) in London. In 1951, after completing his National Service, Benney was awarded the Royal Scholarship to the RCA. He arrived at a critical period. The RCA, under the recently appointed Principal, Robin Darwin, was undergoing a much-needed renaissance. According to influential opinion, the College had reached its nadir in the 1930s. A highly critical report by the Design and Industries Association (DIA), published in 1934, complained that the College was neglecting its proper purpose – providing instruction in industrial design – in favour of the fine arts and the training of art teachers. While the DIA was a voluntary association, although not without influence, an increasing number of official reports were beginning to say much the same. Controversy over the contents of the curriculum was as old as the College itself. The perennial problem, ever since its foundation, was that it was relatively easy to arrive at a definition of what did *not* constitute good industrial design, but it was much more difficult to define constructively what good design really was, and how to achieve it. By 1945

the College was beginning to look like a luxury the country could no longer afford.

It was reprieved by the government, acting for once on a report it had commissioned from the fledgling Council of Industrial Design. The report, presented in 1946, covered the subject of British art education comprehensively and analysed the shortcomings of the RCA in particular. It condemned the traditional division between the arts and the sciences and argued for a much broader and more realistic training for designers than ever before. It also argued persuasively that the Royal College ought to be granted full autonomy and be allowed to determine its own methods for achieving its goals. In order to do this effectively, the author of the report commented: 'Much would, of course, depend upon the Principal, and the initial appointment would be a factor of pivotal importance for the ultimate development of the school.'

It was no coincidence that the author of that report, Robin Darwin, was appointed Principal in 1948. It proved to be an inspired choice. Darwin received the autonomy he requested and, crucially, the proper funding to implement it. He created faculties that cut across the traditional subject divisions and appointed as heads talented and experienced staff whose beliefs were in accordance with his own. The choice of Robert Goodden as Professor of Silversmithing and Jewellery was to prove particularly apposite. Goodden, an architect by training, had worked as an industrial designer before the Second World War, and at the same time had been running a successful architectural practice. He was also the nephew of R. M. Y. Gleadowe, one of the most distinguished silver designers of the 1930s, who had encouraged him to take up silversmithing while he was still a student at the Architectural Association. Goodden's approach was that, as far as possible, his students were trained to serve the needs of the mass-production industries in stainless steel and electroplate, as well as the craft of silversmithing itself. But because the standards of industry were so low, he educated them for the industry it might become, rather than for what it was currently. Teaching was undertaken primarily on a tutorial system. Another Darwinian innovation, in line with his policy of giving his staff every facility they needed, was the appointment of craftsmen-demonstrators, usually on a part-time basis, to provide the highest standards of practical tuition in each of the separate disciplines covered by the College. In this respect, the School of Silversmithing and Jewellery was

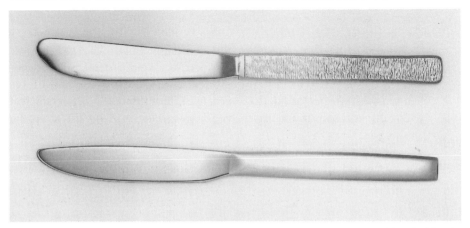

38 Stainless steel table knives, 'Chelsea' (bottom) and 'Studio' (top), manufactured by Viners of Sheffield, *c.* 1965. Both these designs date from the early 1950s and proved to be hugely successful

extremely fortunate in having Leslie Durbin provide that role throughout the 1950s.

One of the privileges of a good tertiary education is that the students not only receive exemplary teaching but they also feed from and stimulate each other. Durbin himself was later to remark that he considered he learnt as much from the students as he ever taught them. Two of Benney's closest friends during his years at the Royal College were David Mellor and Robert Welch. All three shared a passion for fast cars. Mellor ran an MG, Welch a Lancia, while Benney cut a dash with two Crossleys. (Professor Goodden himself drove a huge open Sunbeam.) The connection between an interest in thoroughbred motor cars and fine metalwork is too obvious to need further explanation. But informal discussions in each other's flats often led to intense debates about the future role of design and the part that they themselves would play in it. Years later, Benney recalls Mellor saying: 'We all thought we were going to change the world and turn Woolworth into Olivetti. There was tremendous optimism.'

And for a while, it all seemed possible. However drab the daily circumstances were in the 1950s, the future promised limitless opportunity. Benney, on graduating from the RCA in 1955, took over a small electroplating business in Whitfield Street, just off the Tottenham Court

Road. The lease was on advantageous terms and the space generous enough to provide a studio where, for the next two years, he developed a line of small usable silver for the domestic market. In 1957 he was appointed consultant designer to Viners, the Sheffield manufacturer of domestic silver, electroplate and stainless steel wares; this gave him, for the first time, a degree of financial stability. Viners offered him a retainer of £1,000 per annum, in those days a respectable salary for someone

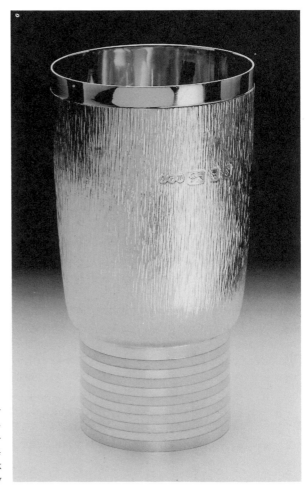

39 Beaker in silver-
gilt and enamel,
with London hall-
marks for 1973–74
and sponsor's mark
of Gerald Benney

Benney's age, which he refused. Showing the business acumen that has always stood him in good stead, he suggested a lower retainer of £800 per annum with the proviso that he would receive, in addition, one per cent of the wholesale value on those lines that he designed. It is not surprising that his annual income from Viners always considerably exceeded their original offer.

At its zenith, in the 1960s, Viners employed over 1,000 workers. Benney designed and supervised the production of some of their most successful ranges of cutlery such as the 'Chelsea' and the 'Studio' patterns. The 'Chelsea' range, with its alternating polished and matt surfaces, was probably the first in Britain to be entirely machine-made using flow-line production methods, and the 'Studio' was the first stainless steel ware to be decorated in high relief. Both lines became international bestsellers. For example, in 1967 the 'Chelsea' pattern was selling up to 4,000 dozen pieces weekly and the 'Studio' some 1,500. These enormous sales were achieved because of good designs being adapted to production efficiency. One of the last developments that Benney pursued with Viners before he severed his connection with them in 1969 was no-scrap blanking, which meant that cutlery could be stamped from sheet steel without any expensive waste.

At the same time as his work for Viners, Benney's silversmithing was beginning to acquire its own distinctive maturity. His early work, particularly that of his student days, was notable for its gently sweeping curved planes and edges. Scandinavian influence is clearly discernible when one compares these pieces alongside the work of Henning Koppel for Georg Jensen, or that of the Swedish silversmith, Sigurd Persson, from the early 1950s. These have remained distinguishing characteristics of Benney's work, particularly when compared to that of his contemporaries, Robert Welch and David Mellor. He remains less 'hard edge' than Welch, always favouring a softer, fuller, more sculptural outline. The surface treatment of his silver throughout the 1950s shows a soft modulated sheen with the hammer marks just evident. It is remarkably similar to the surface quality achieved in the work of Dunstan Pruden and it can be traced back further to the pioneering work of C. R. Ashbee and his Guild of Handicraft, which achieved silverwork of a plain, austere and simple splendour.

In 1958 he began a remarkable series of ceremonial table centrepieces which incorporate large, mainly abstract, sculptural elements within the

disciplined circular section of the bowl. The first of these was the centre-piece given to Leicester University by its first Chancellor, Lord Adrian. By the early 1960s, similar centrepieces, such as the one presented to the Royal College of Physicians by Professor R. A. McCance in 1962 or the bowl with a scorpion cover made for Meister Retailers of Zurich in 1964, showed a richer, more flamboyant and self-assured touch. Nor was this quality confined to his most glamorous commissions; it became evident throughout the entire range of his work. The full swelling outline so characteristic of Benney's designs was still there but it had acquired a new formal discipline.

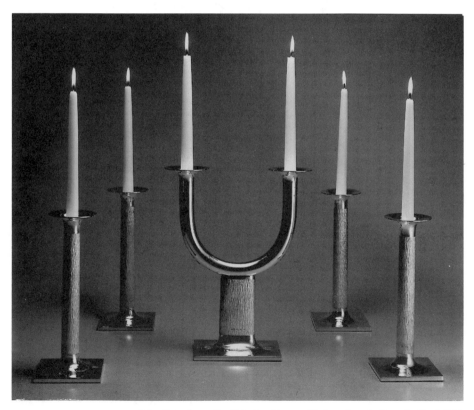

40 Set of candlesticks in silver, with London hallmarks for 1977
and sponsor's mark of Gerald Benney

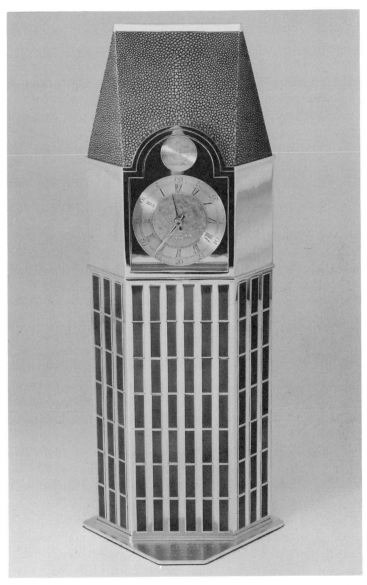

41 Clock in silvergilt with blue enamel panels and green
shagreen roof, quartz movement. London hallmarks for
1993 and sponsor's mark of Gerald Benney

However, the most obvious change in the late 1950s was in his surface treatment of the silver. It was in 1958 that, working in his workshop one day, his hammer slipped through a moment's inattention and the surface was badly deformed. The textured surface was born. This was to be a standard characteristic of Benney's work for the next thirty years and it became so fashionable that it was eventually copied by others, not always with the same degree of success. The distinctive bark-like surface looks deceptively easy to accomplish. It is a tricky technique to execute success-fully, for the chasing used to achieve the effect constantly expands and distorts the surface.

A further significant aspect of Benney's mature work was his intro-duction of enamelling on silver in 1966. This enabled him to enrich his work with deep lustrous colours, often against a textured surface which added to the depth of colour and its excitement. By the early 1960s enamel work on silver had become virtually a lost technique and Benney decided to pay a speculative visit to the firm of Burch Korodi in Zurich, which had produced some of the most interesting modern enamel work in Europe. Arriving at Zurich railway station on a wintry evening, Benny slid on the ice just outside the entrance and badly sprained his ankle. His most pressing priority became the acquisition of a good stout walking stick which he purchased the following day. Idle conversation with the shopkeeper who sold him his stick quickly revealed that the Korodi shop had ceased trading. The trip was promising to develop into a fiasco but, as luck would have it, his informant also knew Korodi's Norwegian master-enameller, Berger Bergersen, who lived close by. Benney and Bergersen were able to meet and Benney eventually persuaded Bergersen to join him in England and teach him and his workforce the intricacies of the art of enamelling. Since 1971, the enamellers in Benney's workshops have received individual recognition by having their initials stamped beside the sponsor's mark on the underside of each piece.

Gerald Benney's career has continued to flourish for the past twenty-five years. At an age when most men are contemplating retirement, he is thriving. In the mid-1990s, approximately 50 per cent of his work is from special commissions. The remainder of his sales comes from a series of stock items where the range has been built up over the years. In May 1994, with his son, the jeweller Simon Benney, he opened a shop in Knightsbridge selling this range and gold jewellery. Since the day of its

opening, the shop has prospered. However, whatever one individual's success suggests, the general evidence is that British silver has returned to being a niche market with a diminished base. The optimism of the 1950s and 1960s when it was believed that the craft skills could spearhead research and development into industrial production which would forever renew and improve itself has since disappeared. The recessionary toll of the 1980s has decimated the traditional British manufacturing base. Companies such as Viners, established in Sheffield in 1907, have disappeared. The name lives on as a distribution badge for stainless steel wares manufactured in the Far East.

Recessionary cycles have always highlighted the need for patronage, particularly where the precious metal crafts are concerned. In this respect, the livery company that safeguards the interests of the silver and jewellery trades, the London Worshipful Company of Goldsmiths, has performed vigorously throughout this century, adopting an interventionist policy. The first step was made in 1925 when the Company started its own modern plate collection to serve as a benchmark and a stimulus to others. Exhibitions and competitions followed which generated much favourable publicity but the Company's real success was often achieved on an informal basis by effecting introductions between silversmiths and potential clients. Graham Hughes, who served the Company as Art Secretary and Art Director for thirty years from 1951, promoted the cause of contemporary British silver with tremendous enthusiasm and panache. Many silversmiths, including Gerald Benney, have Graham Hughes to thank for helping them establish their careers. He convinced many large city companies and corporations that modern silver, designed and made to furnish their head offices and boardrooms, would show how advanced and forward-looking that particular institution was. Two very large commissions undertaken by Benney in the 1960s, one from the Ionian Bank in the City of London and the other from the Corporation of Reading for an extensive set of table silver, were, in each case, a direct result of this. When Graham Hughes retired from the Company to take over the editorship of *Arts Review* in 1981, a warm, witty and heartfelt tribute was paid to him in the June issue of the *Goldsmiths Review*. It is no surprise to learn that the author of this affectionate tribute was none other than Gerald Benney.

A questioning eye: DAVID KINDERSLEY and his workshop

JEREMY THEOPHILUS

THIS PAPER was first given at the Crafts Council on the evening of 2 February 1995. On the morning of that day, I had heard of the death of David Kindersley during the preceding night; whilst still a shock, this had not been unexpected and the family were prepared for its eventuality.

The coincidence was unnerving, but it was somehow very appropriate that the Crafts Council should be in a position to mark the passing of such a pivotal figure not only in the world of lettering, but also of crafts as a whole. I have made very little change to the structure of the original text: it was written to survey David Kindersley's contribution to craft practice, and his death has altered little in my appreciation of his legacy.

To be a working craftsperson in the second half of the twentieth century might, on the face of it, seem to be a lost cause. Everything is stacked against you, from a society that seems to be developing an increasingly lemming-like passion for innovation and novelty, to the ever-encroaching presence of technology within our daily lives. Where can the propagandist for the hand, and all it makes, position himself or herself in such an apparently awesome and increasingly unfamiliar landscape?

In the course of this paper I would like to address the work of a craftsman, and his studio, who formed if not the backbone then certainly a good many vertebrae of the development of lettering in the United Kingdom over the past fifty years. David Kindersley, quite knowingly but with modesty and integrity, bridged a gap between historical precedent and contemporary practice: indeed it is this very self-awareness which has

enabled him to engage with, and make a significant contribution to, innovative developments in lettering.

To understand more fully the true extent of his contribution to the field one should look at his own development as an artist-craftsman and, as importantly, the way in which he used his studio practice not only as a method of producing his own work, but also as a means of encouraging younger makers as assistants and apprentices. In many ways, of all contemporary examples in the crafts, he came closest to the workshop as a formal system of training and, given the current debates about the ways in which craft can be taught, I will focus on this aspect with particular interest.

I have drawn on the written thoughts of David Kindersley because I believe in allowing artists to speak for themselves, particularly when they are as articulate and concise as he was. My own interpretation lies in the juxtaposition of quotations and in doing so I have tried to present a broad picture of the workshop's output without offering any particular or consistent chronology.

'DK' (why is he the only letterer that I know who has the monopoly on a nickname that is abbreviated to letters?) had an international reputation that rested both on his professional skill as a lettercutter and shaper of stone and slate. But, as importantly, he had a reputation as one who thought about what he did and fed that thought into his practice. He addressed this in his introduction to Montague Shaw's book about his workshop where, in 1989, he wrote:

> There are two sides to a lettercutter's nature – or there ought to be. Just like any other craftsman or artist he will be spending a lot of time making things that he feels should be explored and making other things that people want, and these two aspects of his work are quite different. Neither is better or worse than the other ... As time goes on the craftsman himself will learn to give to himself preposterous ideas and he will make something of them. These start as experiments and frequently end as exciting inventions which do not sell but which had to be made. Deep thinking together with a wealth of experience is always rewarding and with it goes the certainty that the thought will one day be wanted.[1]

Of course, David Kindersley could say that with conviction, looking back on his long working life, but it is an assertion that should be acknowledged

by all practitioners. This apparently simplistic philosophy of studio practice is only simple in its description: it is much harder to subscribe to it when sitting alone in the studio with an empty order book and bills to pay! The ability to explore and experiment in one's chosen profession, without thought for the outcome or its immediate application, should be an essential part of any maker's working process.

However, the roots of this philosophy lie in David's own formative introduction to lettering. He never shrank from acknowledging the debt he owed to Eric Gill and in doing so made his own position clearer as well as highlighting those threads of influence which pass from maker to maker in forming the history of craft. DK analysed Gill's philosophy in his essay 'My Apprenticeship to Mr Eric Gill':

> Mr Gill's ideas were of a kind that turned the prevailing hypnotic acceptance of western art completely upside down. He thought and then he made his thought in stone. He put the intellect at least as high as the emotions. The artist was not a special kind of man, but man was a special kind of artist. Anonymity was an ideal and, insofar as a work expressed the personality of the maker rather than the subject, it had failed. Such things are an accident and a hindrance to a perfect rendering of an already complete visual concept within the mind.[2]

Gill's thinking was a synthesis of Roman Catholicism and Hindu theology, deeply influenced by the writings of Ananda Coomaraswamy. We can see here the source of DK's own beliefs, distilled through observation and experience of Gill's practice (and DK was even-handed in his description of the positive and negative aspects of the Gill lifestyle).

David Kindersley was born in 1915 and he was apprenticed to Gill from 1933 to 1936. However, he remembered that the initial impact of lettering upon his life occurred when, as a very young child, he discovered a Samian plate on the site of a Roman cemetery at Welwyn in Hertfordshire stamped with the words VIRTUS FECIT. The path which led him to Gill was that of sculpture, principally with a firm of Italian marble-carvers who translated the work of Royal Academicians from clay into stone.

Whilst the marble-carvers taught DK a rigorous discipline, the processes seemed, to him, dishonest and reading Gill's books encouraged him to search out and convince the author, albeit innocently, of the young enthusiast's potential. What clinched it for Gill was DK's lack of art-school training.

And also of
RoBERT OF THE CHAMBER
father of Pope Adrian IV
ADAM THE CELLARER
Prior ADAM WITTENHAM
ADAM ROUS
Surgeon to Edward III

REMOVED in 1978 from
The CHAPTER HOUSE

SEEK FIRST
THE KINGDOM OF
GOD

42 Memorial tablet for St Albans Cathedral, 1979

Gill's teaching was based entirely on practice: he would first ask the apprentice to draw an alphabet as he or she thought they should be drawn and Gill would then correct it saying 'Here we make an A like this'. As DK wrote: 'In this way, one had before one's eyes the object made without knowledge and experience and its improved version rendered with the deftest skill. Thus, one could measure the difference and see the virtue in things well done'.[3]

Note the absolute reliance on practice as a means of testing and acquiring skill: doing and looking and doing again, forming an equation of activity and analysis upon which to build experience as a craftsperson. Furthermore, Gill had a very straightforward approach to mistakes, insisting that 'the letter should be a faithful rendering of that which one had in the mind's eye'.[4] Correcting a chip by thickening the stroke of a letter would be dishonest and threaten the integrity of the original concept. Instead he advocated a greater attention to the process whilst constantly referring to the idea that was informing it.

Thus trained by example and constant practice, DK left to set up his own studio, continuing to work on commissions fed to him through Gill. The Second World War saw him in Dorset, as a conscientious objector, running what was reputed to be the smallest pub in England, with great success. This was interrupted by Gill's death and DK's move back to the Gill studio and house at Piggotts in 1943 to manage the studio, against his better judgement. However, it is significant that he sorted everything out, particularly in terms of its financial management, so that by the time Kindersley moved to Barton in Cambridgeshire in 1946, he left behind an efficient workshop.

As another link with Gill, DK also brought with him to the new workshop, Kevin Cribb, the son of Laurie Cribb who was 'certainly the finest lettercutter of all time', and who 'seemed to have learned all there was to know years before – his work had become instinctive'.[5] Laurie had been the mainstay of Gill's workshop at Ditchling, and Kevin's relationship with the Kindersley Workshop has been similarly important.

DK and Cambridge seemed to be partners in a very long-standing relationship, based initially on introductions to Cambridge University Press for which DK produced a range of lettering for its buildings. His lettering can also be seen on street-names in the city and elsewhere: they are certainly an important factor in the way visitors and residents 'read' the experience of navigating and living in Cambridge.

The persistence with which DK pursued his conviction that the old signs should not be replaced simply for the sake of something 'new' illustrates the way in which makers can also be doers, and if that means arguing an idea through the maze of planning bureaucracy, then so be it. Such tenacity is an essential part of the lettercarver's studio practice, not just with public authorities but also in dealing with private commissions.

I should not forget to mention at this stage the contribution made by DK to the formation of the forerunner of the Crafts Council, the Crafts Centre, as it was, in Hay Hill, London. He spent some time as chairman but withdrew as the pressures of managing a directorate with insufficient funding took too much of his precious time. The role played by David Kindersley in the development of the Crafts Council is an important one which is addressed in greater detail by Tanya Harrod in her history of the Council.[6] Suffice it to say that it was by no means an easy birth with many involved who were keen to establish their own vision of what the Council should be like, and with a rich stock of argument to support it.

In 1967 the workshop moved to the Chesterton Tower in Cambridge itself and in 1977 DK moved to an infants' school, the ground floor of

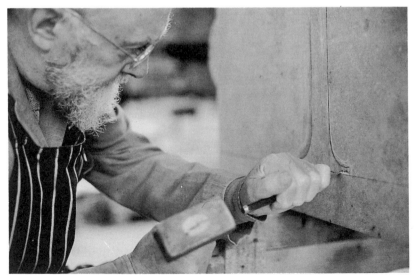

43 David Kindersley working on fascia stones for quayside, Dordrecht

which he converted into two large, light and airy studios, adjoining office, computer and archive rooms, with living accommodation above. The borderline between the two areas is, however, difficult to define as for DK each was closely linked.

In 1976, a new assistant had arrived at the workshop from the Netherlands, Lida Lopes Cardozo, whom DK married in 1986, and who has increasingly taken the central role in the management of the studios. The partnership also offered the opportunity for a number of significant commissions in Holland.

The rhythm of studio life is what motivated and stimulated DK's own practice, and he was quick to point out that it is a two-way relationship between assistant and 'studio manager'. Nico van der Lof, in his introduction to the catalogue of an exhibition of the workshop in the Netherlands in 1987, underlines this point:

> The apprentices need a strong character not to lose their own artistic identity, and a lot of wisdom on the part of the 'master'. In the case of David Kindersley's workshop both the character and the wisdom are clearly present and the whole atmosphere is one of amiable creativity. This is felt on the floor of the workshop though David and his fellow workers do not spare each other advice and criticism if they are necessary or wanted.[7]

Achieving and maintaining this level of positive communication is far from easy: there are a number of factors that can affect the stability of such a group of individuals. Sustaining the order-book, dealing with clients, planning bodies and contractors, supervising assistants at differing levels of skill: these inevitably take priority over creative 'hands-on' activity and produce both internal and external tensions.

The ability to allow personal development (and mistakes) at the same time as protecting the standards of the workshop's output is made all the more difficult if one is prevented from active involvement on the shop-floor by the pressures of management. This was certainly the case in the last two years of David Kindersley's life, when the workshop had probably never been busier, running with a complement of five staff, but when Lida certainly had less and less time for lettercutting herself, particularly once DK had retired from active participation.

DK defined the nature of a workshop quite precisely, yet without losing sight of its relationship to the inner essences of life:

What is a Workshop? It is a place where workers work and build a micro-cosm of life. It is in many ways like a temple, a place of rethinking and dedication, echoing each passing day and adjusting to the demands of its hitherto unknown clientele. Together with the Workshop and the Material, the Client forms a very important part of a triad, without which nothing much would happen in this life. The Workshop should be a living organism and if it isn't its further existence is pointless.[8]

He always recognised the importance of the client, not just as a source of revenue but, more generously and perceptively, as a direct influence upon the maker's practice: 'lucky is the artist craftsman who likes his clients and is prepared to listen to them for they guide him along paths that he would never have taken without their help'.[9]

Rereading this still comes as something of a surprise, given the long and tortuous history of artist–client relationships, from Michelangelo to Graham Sutherland. There is no doubt, however, that this attitude repre-sents an understanding of the maker being in sufficient control of his or her skills to be able to meet the client more than halfway and rise to the creative challenge.

It follows therefore that those who have passed through the Kindersley Workshop will have absorbed this philosophy in some measure, but, like DK himself with Gill, will also have filtered the experience and recreated their own 'temple', adjusting it to be a microcosm of their own life. As well as Kevin Cribb, the letterers David Dewey, David Parsley, David Holgate and Richard Kindersley have all served apprenticeships, as – more recently – have Bettina Furnee, James Sargeant and Dan Woodall.

In thinking about the Kindersley Workshop and its relationship to the current training of lettercutters, it is clear that there is a widely recog-nised perception of its reputation as a proving ground for the profession. However, the point at which potential assistants approach it has altered, and it has been noticeable that more people see the association with the Kindersley name to be as important as what can be learnt. Perhaps this has been the result of more college courses offering a more businesslike approach to the profession, hence encouraging potential letterers to take a less realistic approach to the implications of an apprenticeship. This means absorbing oneself in the practice of the workshop in order to discover one's own creativity, and such a letting-go of individuality can be hard.

The Kindersley trademark is the cut or incised letter, born out of an early interest in the three-dimensional form, and refined in Gill's studios. At the heart of this lies the ability to draw, and it is no surprise to hear DK say: 'it is the arrangement of letters that gives me the greatest pleasure of all, but then I must admit that I have to draw the letters too. I guess I like drawing letters most of all.'[10]

In 1967 DK was invited to the United States as a Senior Research Fellow at the William Andrews Clark Memorial Library, University of California, Los Angeles, to organise the recently acquired Eric Gill Collection. While there he began to experiment quite freely with alphabets intended for printing and hand-colouring: ' I just wanted to see what happened if I made a letter which I could hardly visualise, and what fun I had!'[11]

This continued into the 1970s on an occasional basis, where DK experimented with 'sayings' (mostly those of Idries Shah): 'One tries to create a 'set' that will lead the reader or viewer deeper into the meaning behind the words.'[12] He also took the music of Stravinsky from which to draw inspiration for the interpretation of titles of his works.

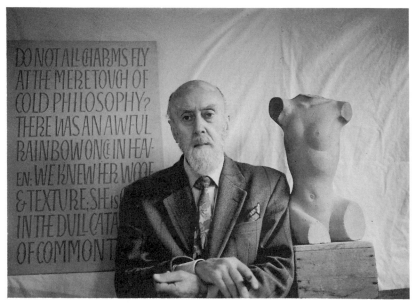

44 David Kindersley with examples of figurative carving and lettering, 1994

Each of these explorations had their own effect upon the central work of the studio, there being 'much to influence more routine inscriptions'.[13] Indeed, the entrance sign to the workshop itself is developed from thematic ideas dating back to this period of work.

A constant curiosity about the arrangement of letters, which DK has identified as being at the heart of his practice, is also the motivation for his other major contribution to lettering. Recognising the increasing importance of computer-generated lettering and before it the photoset letter, as against the more traditional methods of printing, he began to investigate ways in which a more appropriate method of spacing letter-forms could be devised:

> Kerning seems to generate a great deal of heat amongst those who were trained in the use of metal type. The word should be forgotten when spacing letters. For a scribe or draughtsman of letters the overlapping of one letter by another is simply spacing. He will almost certainly be unaware of the word 'kerning'. And so it is with a sensible program based on the eye.[14]

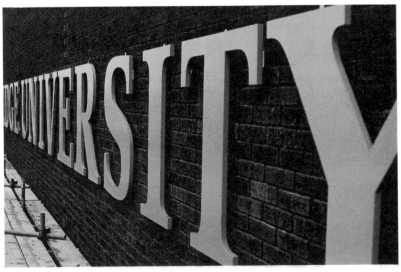

45 Exterior lettering of Cambridge University Press building

According to DK's definition of good spacing, 'each letter should appear to be in exactly the centre between its two neighbours ... Put another way, any letter should occupy a passive position between its neighbours.'[15] As a final commendation to this system we should add the words of Hermann Zapf, who has written:

> We are not so presumptuous as to wish to educate a reader, but we should try to open his eyes to good typography and even spacing between letters – human typography as I would call it. David Kindersley's LOGOS works. There is no excuse any more for bad inter-character spacing or imperfect kerning.

The first public evidence of the LOGOS spacing system was for signage at the new Cambridge University Press building, which led to a consultancy with Letraset, who had printed the lettering for this commission and were so intrigued by the system that it became standard on all their sheets of rub-down lettering.

This is just one more example of DK's curiosity, guided by basic skill and a persistence to see a project through, whatever the obstacles. I would argue that these qualities are partly the legacy of Eric Gill, and whilst DK did not produce typefaces of the international reputation of Gill Sans or Perpetua, he was a considerable force in the world of lettering and typography – as considerable as one man can be, that is, without large amounts of commercial support.

In her book, *In the Red Kitchen*, Michèle Roberts is writing through the voice of a young Egyptian princess as she describes the power of the written and carved word in her culture:

> Stone is cut into, cut out; this absence of stone, this concavity, this emptiness, yet means a fullness: the words appearing, their presence overcoming the absence of what they denote, filling emptiness with meaning, creating the world over again. Writing I live: I enter that world beyond the false door of the tomb; my existence continues throughout eternity.[16]

We recognise this power of the written, incised, carved, engraved word today, in our own culture, although it has been blunted by over-exposure and has been taken for granted. The power to affect still resides, however, in the creativity and skill of craftspeople such as David Kindersley and those who have been touched by and learned from his abilities.

A shaman of the twentieth century? Perhaps, but certainly one who was always led by his own questioning eye.

Notes

1 M. Shaw, *David Kindersley: His Work and Workshop* (Cardozo Kindersley Editions and Uitgeverij de Buitenkant, Cambridge, 1989).

2 'My Apprenticeship to Mr Eric Gill', published in *Crafts* (July/August and September/October 1979), and in J. Houston (ed.) *Craft Classics Since the 1940s* (Crafts Council, London, 1988).

3 *Ibid.*

4 *Ibid.*

5 *Ibid.*

6 T. Harrod, *History of the Crafts Council*, Factfile No 3. (Crafts Council, London, 1994).

7 *David Kindersley's Workshop* (Staatsuitgeverij 'S Gravenhage, 1987).

8 Cardozo Kindersley, *Letters Slate Cut* (Cardozo Kindersley Editions, Cambridge, 1990).

9 Shaw, *David Kindersley*.

10 D. Kindersley and L. Lopez Cardozo, *Graphic Variations* (Cardozo Kindersley Editions, Cambridge, 1979).

11 *Ibid.*

12 *Ibid.*

13 *Ibid.*

14 *David Kindersley's Workshop.*

15 *Ibid.*

16 M. Roberts, *In the Red Kitchen* (Mandarin Paperbacks, 1991).

The modern jewellery of
GERDA FLÖCKINGER

TANYA HARROD

THE JEWELLER Gerda Flöckinger was born in Innsbruck in 1927, coming to England at the age of ten after the Nazi annexation of Austria. She was a child when she arrived here – much younger than a fellow Austrian, the potter Lucie Rie (1902–95), a family friend; younger than two German refugees Hans Coper (1920–81) and Ruth Duckworth (b. l919), both to become distinguished potters; and younger than Ralph Beyer (b. 1921), who was sent out of Nazi Germany via Greece as a sixteen-year-old to Gill's workshop to learn lettering. But like them she had come from a middle-European culture which had embraced modernism in architecture, furniture and the applied arts to a far greater extent than in Britain. 'Tudorbethan' architecture, chintzes, a preference for antiques and for antique Victorian jewellery were not part of her cultural baggage.[1] She was probably more politically aware than most young British girls of her age.[2]

On her arrival in England in 1938 she was sent to the Caldecott Community (then near Maidstone).[3] The Community was co-educational and 'progressive' in spirit. Gerda remembers lying in bed in the Community sick room reading the classic English illustrated children's books. There was country dancing, Dalcroze eurythmics, community 'aims' and an emphasis on character-building, partly inspired by the educational philosophy of the founder of Gordonstoun, Kurt Hahn.

After a further spell at South Hampstead High School for Girls (1943–45) Flöckinger went in 1945 to St Martin's School of Art where she spent five important if inconclusive years painting and drawing, the last year in a small postgraduate group. The crucial turning-point for Flöckinger

was a series of visits to Continental Europe. In 1951 she was in Paris *en route* to Italy and was profoundly impressed and delighted by the jewellery of Jean Fouquet. In 1952 she was in Italy, at the Venice Biennale and saw modern Italian glass, furniture and ceramics. In Ravenna in the summer of 1952 she decided to study jewellery and in London, in the autumn of 1952, she saw 'Contemporary Jewellery', a student show at the Central School of Arts and Crafts. She started jewellery evening classes there in October 1952 and after Christmas was taken on as a full-time student. The following year she visited Mario Masenza's jewellery shop in the Via del Corso in Rome which showed work designed by contemporary fine artists such as Afro, Pietro Consagra and Lucio Fontana.

Just after the Second World War the Central School of Arts and Crafts was bursting with teaching talent recruited by the new principal, the Scottish painter William Johnstone (1897–1981). He had inherited a great craft-based art school, shaped by its first principal W. R. Lethaby and much imitated on the continent. Conscious that the Central School had, as he put it, acted as parent to the Bauhaus, he introduced a cohort of youthful fine artists to teach, using Basic Design principles – defined by Johnstone as 'a way of teaching a grammar of design … in a twentieth-century idiom'.[4] They were intended to act as Masters of Form (to employ Bauhaus terminology) whilst the more traditional staff, noted for their technical skills, fulfilled the role of Masters of Crafts.[5] In 1947, on Johnstone's arrival, the School of Silversmithing and Jewellery, headed by A. R. Emerson, taught a conservative range of skills. Johnstone sent in the painters Mary Kessel (b. 1914) and Richard Hamilton (b. 1922); neither had technical jewellery skills. Their role was to bring in new creative ideas.[6]

None the less, despite these developments at the Central School, the world of jewellery was still dominated by the trade. In 1937, two years before the war, Nikolaus Pevsner had conducted a survey of industrial art in Britain. He found the standard of jewellery design disappointing – with the high-quality end of the trade conventional in the extreme and cheap stamped and assembled jewellery equally lacking in design adventurousness.[7] In 1955 Pevsner's survey was updated by Martin Farr but the section on jewellery remained unchanged. The only 'modern' jewellery Farr found to mention was European – Henning Koppel's designs for Jensen then available in Britain and the glass jewellery made in London by the Viennese *émigré* Fritz Lampl's firm Bimini.[8]

Emerson had asked the young Flöckinger what kind of jewellery she wanted to make. She said, 'Modern jewellery.' 'Yes dear,' he replied, 'lots of people want to do that but you won't be able to make a living at that – so we'll teach you to make conventional jewellery and you can make modern jewellery in your spare time.' Despite this discouraging welcome, when Flöckinger arrived in 1952 Johnstone's introduction of fine artists to the school was having an effect. She found Hamilton's teaching perplexing but Mary Kessel was a creative presence and in 1953 Hamilton left and the painter Alan Davie (b. 1920) was brought in. Davie was in touch with the most advanced painting in Europe and America. His own painting revealed the influence of Klee and Picasso but also a range of non-European so-called primitive art. He had been making jewellery since 1949 and was strongly attracted by ethnic and pre-Columbian artefacts.[9] The presence of these fine artists created a context for attempting to create a new kind of jewellery despite the essentially conservative trade nature of the school as run by Emerson.

A range of sources of inspiration was available to artists and craftsmen and women looking for a new language of expression in the 1950s. There was a continuing interest in non-European, chiefly African, oceanic and pre-Columbian, art. This kind of cross-cultural influence can clearly be seen in the jewellery of Alan Davie. But another subject of interest among young artists in the 1950s also seems relevant to Flöckinger's work. Like many artists she noted the new landscape of cell structures as revealed by micro-photography and high-speed photographs like the 'splash of milk'. (This was a famous image which certainly fed into the visual language of 1950s design and applied art.)[10] She remembers studying an issue of *Life* magazine copiously illustrated with micro-photography. There are plenty of early pieces by Flöckinger which suggest the inspiration of cell structures. They are 'organic' but at one remove from nature as perceived by the naked eye.

When we look at Flöckinger's work from about 1954 onwards (the year of her marriage to Ron Houghton) we certainly see a new landscape in terms of existing jewellery. In 1954 she briefly worked for the Polish designer and technician Bialkevich in his Grays Inn Road factory making mass-produced costume jewellery. The design quality there was low. Flöckinger recalls: 'Mainly, existing pieces were bought from France, used, then cut up, put together differently, used again, and so on, until there

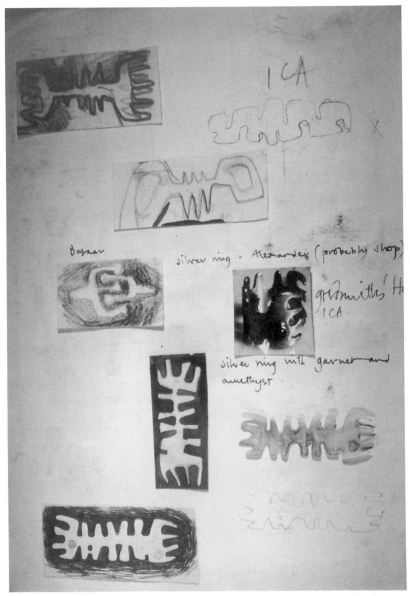

46 Notebook page with a photograph of a ring
and associated drawings, mid 1950s

47 Detail of necklace in silver with cabochon quartz, early 1960s

were no more permutations.' Her time there was brief and she returned to the Central School on a part-time basis until 1956. In that year she and other students mounted a special display for Graham Hughes, the art secretary at the Goldsmiths' Company, and as a result she won a £10 travelling prize. The connection with Graham Hughes, a dynamic and daring patron of innovative jewellery both for the Goldsmiths' Company and on his own behalf, was to become extremely important for her future career.

In her early work Flöckinger pioneered the use of non-precious and unconventional materials in jewellery. For instance, she used copper, wooden beads and seed pods. Some of her choices were Arts and Crafts ones such as her preference for cabochon instead of cut stones; she started enamelling while at the Central School – an art form that had been popular with Arts and Crafts jewellers and metalworkers. But she used the technique in a contemporary way. Like her Arts and Crafts predecessors, her enamels reflect the fine art interests of the period – prehistoric cave paintings, the tachiste paintings of the 1950s School of Paris, the art of Paul Klee and the configurations of cell structures. Flöckinger was particularly interested in Etruscan, Greek and Roman jewellery and early medieval jewellery. At that stage most of her work was made from thin sheet copper and silver, some cut and shaped in a fashion reminiscent of Alexander Calder's mobiles. She employed, and continues to employ, what Graham Hughes called 'a two-dimensional approach to a three-dimensional art'.[11] Many early pieces had a Scandinavian quality but were far more idiosyncratic, imaginative and bohemian than Scandinavian work of the period.

The key to Flöckinger's great range of work of the 1950s and 1960s is to be found in her notebooks. They contain all kinds of approaches to design and her drawings range from careful diagrammatic renderings of individual pieces, to bold rough sketches, to abstract painterly looking designs reminiscent of her enamels. The fact that she was already a highly original jeweller was underlined by her early exhibiting venues. She had pieces in Mary Quant's shop Bazaar when it opened in 1955. A little earlier she met Dorothy Morland, the then director of the ICA, and showed jewellery there from 1954 to 1964. These two places were the epitome of the avant-garde in fashion and fine art and design in the mid-1950s.

The start of the 1960s was marked by an impressive international exhibition held at Goldsmiths' Hall in collaboration with the Victoria and

Albert Museum. This was initiated by Peter Floud, Keeper of the Circulation Department of the V&A (who died before the exhibition opened) and taken over by Graham Hughes.[12] In this show, which

48 Silver bracelet with cabochon tourmalines and turquoise, 1968.
From the catalogue *Flöckinger/Herman* (Victoria and Albert Museum, 1971)

surveyed European jewellery from 1890 to 1961, Flöckinger emerged as a striking modernist showing beautifully constructed necklaces and enamelled pieces which held their own alongside the work of continental jewellers like Torun Bulow Hube (b. 1927) and Flöckinger's contemporary and friend at the Central School, E. R. Nele (b. 1932). Apart from Flöckinger, the British section included an interesting group of jewellery designed (and, in a few instances, made) by painters and sculptors including Mary Kessel, Robert Adam, Bernard Meadows, Elizabeth Frink and William Scott. There were also pieces by the jewellers Andrew Grima (b. 1921), John Donald (b. 1938) and David Thomas (b. 1938). They had picked up fashionable interest in crystal structures though they used these sources of inspiration in a less subtle way and, at that date, were using more expensive materials than Flöckinger. In 1961 Grima, for instance, would have had rather different kinds of client and with his large workshop employing young designers he was in many ways closer to the trade jewellers like Garrard's with whom he was beginning to compete. Flöckinger was in a more avant-garde world as regards artistic ambitions.

In 1962 Flöckinger started teaching at Hornsey School of Art, creating a remarkable course that united Basic Design principles and a highly effective technical training.[13] This is in itself worth noting because, by the 1980s, Basic Design courses were identified as encouraging innovation at the expense of skill. This was never the case with Flöckinger's course. None the less, skills were learnt in order to carry out ideas and it is this conceptual interest that continues to inform the work of her best pupils such as Charlotte de Syllas, David Courts and David Poston. At the heart of the course developed by Flöckinger at Hornsey were a series of introductory exercises. The first involved the manipulation of a square with seven or nine holes arranged in any way whatever. This exercise additionally taught the specific skills of squaring up a sheet of metal, drilling it, using a frame saw and filing and polishing. The second exercise involved forming three, five, seven and nine spheres and organising them into a structure with one other element allowed. This added the skills of raising domes and soldering to the vocabulary. The third exercise involved taking sheet metal and using cutters and pliers to shape 3D forms of any kind. Later in the evolution of the course Flöckinger added a walk-about for found material; 'all objects – if legally found – are acceptable' went the rubric. The first piece of fully realised jewellery made by a student had to

evolve from these exercises. The course was dependent on a generous staff–student ratio – there were twenty-four hours of solid contact teaching per week. As the course proceeded students evolved their own projects using their sketchbooks combined with regular consultations with Flöckinger. The remarkable nature of this course is indicated by the fact that in 1964 the Arnolfini Gallery in Bristol showed the whole student output since 1962 and in 1965 this was displayed at Goldsmiths' Hall and the entire body of work purchased by Graham Hughes, the Hall's artistic director, for the Worshipful Company of Goldsmiths' collection.

At Hornsey, as many student pieces by Charlotte de Syllas in the Goldsmiths' collection reveal, a lot of technical experimentation was going on. Flöckinger herself was becoming increasingly interested in fusing metals – first mainly silver and then introducing gold. In fact she was begining to create a new visual vocabulary that was quite different from her work of the 1950s and early 1960s. After the strike at Hornsey in 1968 she did not return to teaching. Instead she concentrated on making work for a solo show at the Crafts Centre of Great Britain (now called Contemporary Applied Arts) at the invitation of the then chairman Graham Hughes.

At this exhibition Flöckinger unveiled a new jewellery which bore little relation to anything being made by anyone else and which in some ways seems to have been a turning-away from rational modernism and the Scandinavian and American influences on her early work. She explains:

> Once I began to fuse I also started on increasingly complex ideas and my work gradually took me longer and longer to evolve ... I was really trying to see how far the metal could be pushed, what it would do, how it would react. I roared into gold (then $35 an ounce) with a huge melting flame which I would never do now.

Her new work had a good deal to do with a strand of decorative modernism exemplified by the early twentieth-century activities of the dress designer Paul Poiret, by the paintings of Henri Matisse and by the sets and costumes of *Ballet Russe*.[14] This alternative modernist tendency made a subversive reappearance in the mid-1960s fuelled by a surge of hedonistic consumerism that celebrated androgyny, the erotic and the ornamental.[15]

Flöckinger's late 1960s jewellery seems to be at the heart of this revolt

in style, similar in mood, for instance, to the posters designed by Michael English and Nigel Weymouth.[16] Their draughtsmanship, characterised by an exquisite and rhythmic Beardsleyesque linearity, has a good deal in common with Flöckinger's own drawings of the period. Then again Arts and Crafts jewellery comes to mind – Henry Wilson would have admired her elaborate neckband of 1968 and liked its cabochon stones. The Arts and Crafts Movement, art nouveau and Klimt were popular 'rediscoveries' of the 1960s. And perhaps the 1960s interest in the art of the 1890s revived memories of those childhood days when, newly arrived at the Caldecott Community, Gerda first read stories illustrated by Arthur Rackham, full of mermaids and pearl fishers sporting in bubbling seas, and flew across the magical landscapes of *The Rubáiyát* of Omar Khayyám in the company of Edmund Dulac.

49 A pair of rings in 18-carat gold with an oval moonstone, coloured diamonds and a single cultured pearl, 1993

50 Ear-rings in
18-carat gold with
coloured diamonds
and cultured pearls,
1992

Flöckinger's new fused work, in all its lush baroque intensity, had a remarkable impact. In 1971 she was invited to exhibit at the Victoria and Albert Museum in a major show which she shared with the glass artist Sam Herman.[17] Here Flöckinger's new complex language of excess was taken to new heights. The catalogue of the show is of interest – it was illustrated with brooding black-and-white photographs by Mark Hamilton, which could hardly be more different from the 'normal' photography of jewellery that emphasises its reflective, bright and, not least, precious qualities.

Over the years Flöckinger has become increasingly skilful and controlled as a maker.[18] She works with enormous technical finesse. In that sense her jewellery (though not her use of fusion techniques) has changed since the 1970s. In 1991 she was awarded the CBE for her services to jewellery design. Flöckinger is now a jeweller with a capacity for innovation combined with remarkable grandeur of effect. As she explains: 'I have lost some of the wonderful spontaneity I had, but I have a better repertoire of what I know will work. Even so, the technique is one of total risk at all times of total melt-down or irreparable damage. The secret is to keep just on the edge of that, and stay there.'

At the heart of the consumption of avant-garde jewellery there is an apparent paradox. Advanced art during this century has been dominated by a version of modernism that is rooted in the rejection of conspicuous consumption. Much avant-garde jewellery is characterised instead by conspicuous parsimony or austerity. Much modern making of every kind is characterised by what anthropologists call 'a refusal to transact'.[19] Flockinger has lived all these paradoxes. She has pioneered the use of non-precious materials and conceptual ways of working. She has been modern in a clean-cut Scandinavian way and in an alternative way – in the *Ballet Russe*, Paul Poiret way. The story of her life is an extraordinary one. The story of her art is even more remarkable – especially the unexpected and dramatic shift in her work from one modernity to another between 1965 and 1968.

Notes

My thanks to Gerda Flöckinger for her help in preparing this article. Direct quotations attributed to her come from a taped conversation held on 25 March 1994 and a typed autobiographical account lent to me by Gerda Flöckinger.

1 For a general overview see M. Schoeser (ed.) *Influential Europeans in British Crafts and Design* (Crafts Council, London, 1992). On Rie's Austrian background see J. Houston (ed.) *Lucie Rie: A Survey of Her Life and Work* (Crafts Council, London, 1981), pp. 11–21. Flöckinger is an admirer of Rie for 'the very fact that one could consider this kind of work as a vocation and make one's living at it.' Also, T. Birks, *Hans Coper* (Collins, London, 1983), pp. 9–18; T. Harrod, 'Free Spirit: Ruth Duckworth', *Crafts*, 85, (March/April 1987), pp. 32–5 and 'Ralph Beyer, The First Forty Years, Dot-The-I', *Crafts* (Spring 1991), pp. 48–53.

2 Her paternal grandfather was one of the founders of the Social Democratic Party in Austria, her father an active socialist. Flöckinger was a founder member of CND.

3 See L. M. Rendel, *The Caldecott Community: A Survey of Forty-eight Years* (Caldecott Community, Ashford, 1961).

4 W. Johnstone, *Points in Time: An Autobiography* (Barrie & Jenkins, London, 1980), p. 221.

5 *Ibid.*, p. 211, pp. 216–37.

6 *Ibid.*, p. 254–58. Also pp. 260–1 where Johnstone mentions Hamilton in the School of Industrial Design. Flöckinger has photographs of the show 'Contemporary Jewellery' whose innovatory quality was, she believes, largely to do with the teaching of Hamilton, Kessel, Patrick Heron and Victor Pasmore. The poster was designed by Hamilton's friend and fellow Independent Group member Nigel Henderson. Kessel had earlier been co-opted by the Needlework Development Scheme to enliven embroidery design. The results were toured as 'An Experiment in Embroidery Design', Arts Council, 1950.

7 N. Pevsner, *An Enquiry into Industrial Art in England* (Cambridge University Press, Cambridge, 1937), p. 108–14.

8 M. Farr, *Design in British Industry: A Mid-century Survey* (Cambridge University Press, Cambridge, 1955), p. 49 and Plate 20. For Flöckinger's own similarly unenthusiastic assessment of British jewellery five years on see G. Flöckinger, 'Jewellery in England', *Crafts Review*, 6 (1960/61), pp. 59–61.

9 M. Tucker (ed.) *Alan Davie: The Quest for the Miraculous* (University of Brighton Gallery and Barbican Art Gallery, London, 1993) gives an overview but ignores Davie's jewellery. On Davie at the Central see Johnstone (1980) p. 256

and A. Ehrensweig, *The Hidden Order of Art* (Paladin, London, 1970), pp. 120–1.

10 Illustrated as the frontispiece to D'Arcy Wentworth Thompson, *On Growth and Form* (Cambridge University Press, Cambridge, new edition 1942). An early ring by Flöckinger illustrated in her *Crafts Review* article bears a remarkable resemblance to this image.

11 Graham Hughes, 'Gerda Flöckinger', *The Connoisseur* (February 1964), p. 111. This is a good overview of Flöckinger's early work.

12 'International Exhibition of Modern Jewellery 1891–1961', organised by the Worshipful Company of Goldsmiths in association with the Victoria and Albert Museum at Goldsmiths' Hall, 1961.

13 For Basic Design see M. de Saumarez, *Basic Design: The Dynamics of Visual Form* (Studio Vista, London, 1964). Flöckinger dislikes the suggestion that she was influenced by Basic Design ideas current in the early 1960s but certainly her course shares some principles associated with this system of teaching, in particular its rejection of stock solutions and second-hand references. She may have reached her position through discussions of 'basic Bauhaus principles' with Clive Latimer the furniture designer and through her dissatisfaction with the way she had been taught at the Central School.

14 Flöckinger's mother was a dressmaker and dress designer and Flöckinger herself has had an abiding, informed and highly intelligent interest in clothes and high fashion.

15 These ideas are discussed in P. Wollen, *Raiding the Icebox: Reflections on Twentieth-Century Culture* (Verso, London, 1993) p. 1–30.

16 That her work was seen as the epitome of 1960s culture is suggested by its inclusion in the film funded by the Central Office of Information (1967) *Opus: Impressions of British Art and Culture* which also included artists Eduardo Paolozzi and Alan Davie, designer Mary Quant, footage from Peter Brook's film *Marat/Sade* as well as the Beatles and Dudley Moore.

17 See G. Flöckinger and S. Herman, *Jewellery by Gerda Flöckinger. Glass by Sam Herman* (Victoria and Albert Museum, London, 1971). This was the second in a short-lived series of contemporary craft exhibitions organised by the Circulation Department. The first, devoted to Hans Coper and Peter Collingwood, was held in 1969.

18 Compare the catalogues of her two solo exhibitions held at the Victoria and Albert Museum in 1971 and 1986.

19 This suggestive phrase is to be found in Mary Douglas, Baron Isherwood *The World of Goods: Towards an Anthropology of Consumption* (Penguin, Harmondsworth, 1978), p. 140.

99146
£40 -